I love animals. I love them mainly for their innocence, and I love photographing them for many other reasons, such as their beauty, colors, textures, uniqueness, form, etc.; and naturally, for their expressions.

Sometimes, if one is very observant, many creatures will display a range of expressions that are very similar to ours. These can be very fleeting, but if your finger is ready on the shutter, and your eye is following their every move, they can be captured for all time.

Of course, the human-like expressions come from the apes and monkeys, but just about any of them can convey an attitude, a pose, or a certain look that can well be termed as a "communicative moment."

Sometimes, their photographs need no comment at all, just their presence is more than enough, even with no discernible expression. But I especially enjoy it when they seem to be saying something, that to me, looks very expressive and funny. At those times, I just can't help but imagine a caption for my thoughts. I like to think that if they could reason and go along with this, they would certainly love to be in on the game.

About Dan Barba, photographer:

Originally having practiced as an Engineer, and not finding the work fulfilling, I picked up the photo hobby, or 'bug.'

Eventually, I ended up as a full time pro photographer in South Florida. Soon thereafter I moved to Manhattan, NY with my wife, Olga. There, I worked with the leading Advertising Agencies, corporations and magazines, initially shooting fashion and beauty and later on, large format still life commercials for single ads and/or campaigns.

Working with Advertising/commercial clients is extremely demanding and competitive, with many creative restraints, and the equipment/business investments considerable, although the financial rewards are great. One has to execute very specific photo layouts exactly how the concept demands and a lot of money can be involved in the project. So, it's got to be done right, the first time. All the while, appearing as cool as possible. Wheew!

On any given day in my studio, there could have been an Art/Creative Director from the Ad Agency, any number of clients, attorneys, client/account representatives, an Art Buyer, models, prop and make-up/hair stylists plus several assistants, not to mention my Agent. That is a lot of people intruding on one's private mental world. It is highly intense and it can only be done sanely for a given number of years. Some photographers can do it indefinitely, but many don't even try; nor should they, I believe. I certainly didn't.

So at one point, after a fruitful career, I retired. But I continue to shoot (for myself only) personal creative work, which is what I originally went into photography for. No more creative constraints now. Anything that strikes my eye is game. This is what really fulfills me, and not only shooting pictures, but hand-holding them all the way to the finished concept through the wonderful medium of today's digital workflow.

Now, I would like to share this small collection with all those with an appreciative eye.

No animals have been retouched in this book. All expressions are original and real.
Only color correction, dust removal & cropping have been done.

© 2012 by Dan Barba

A CM BOOK

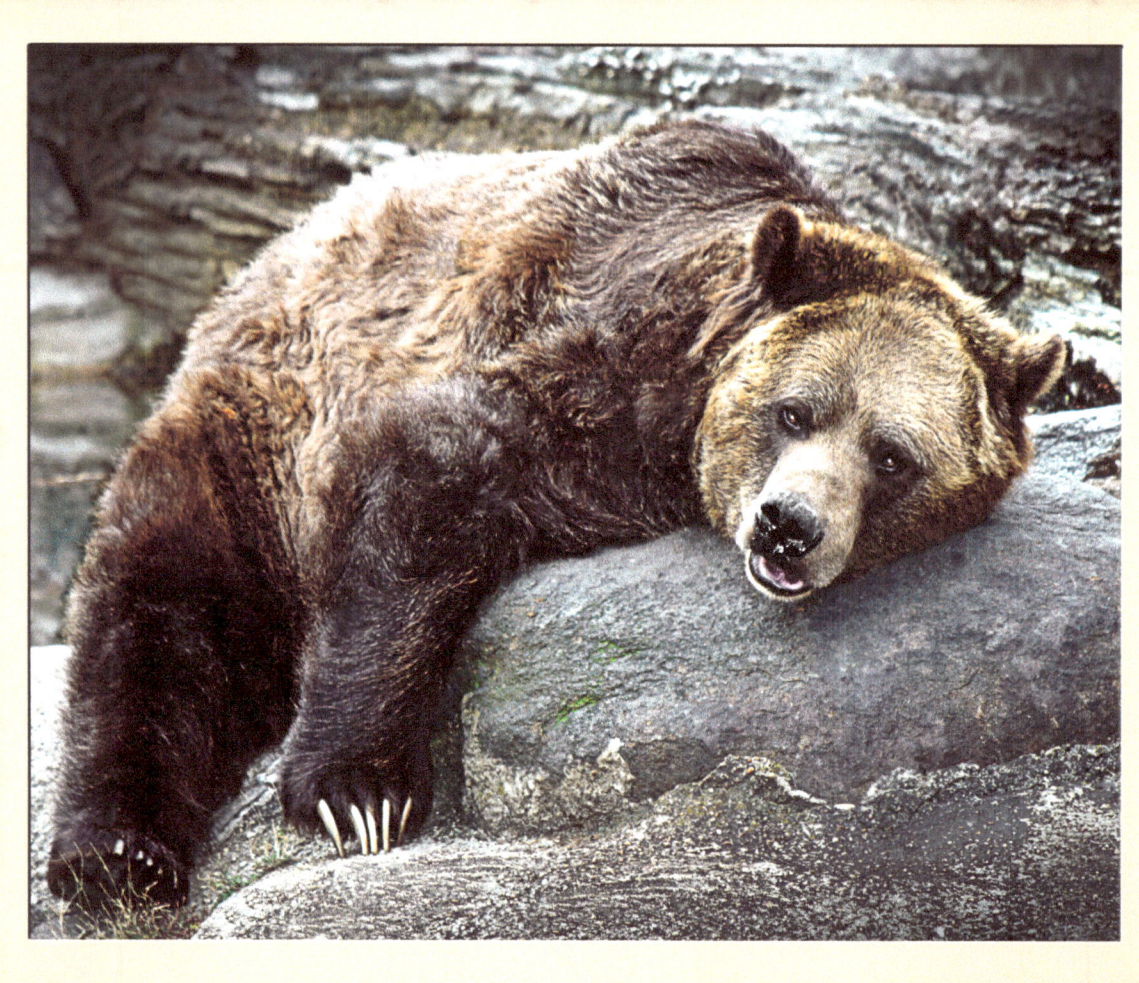

You see, my psychic says I was a Bear Sloth in a past life...

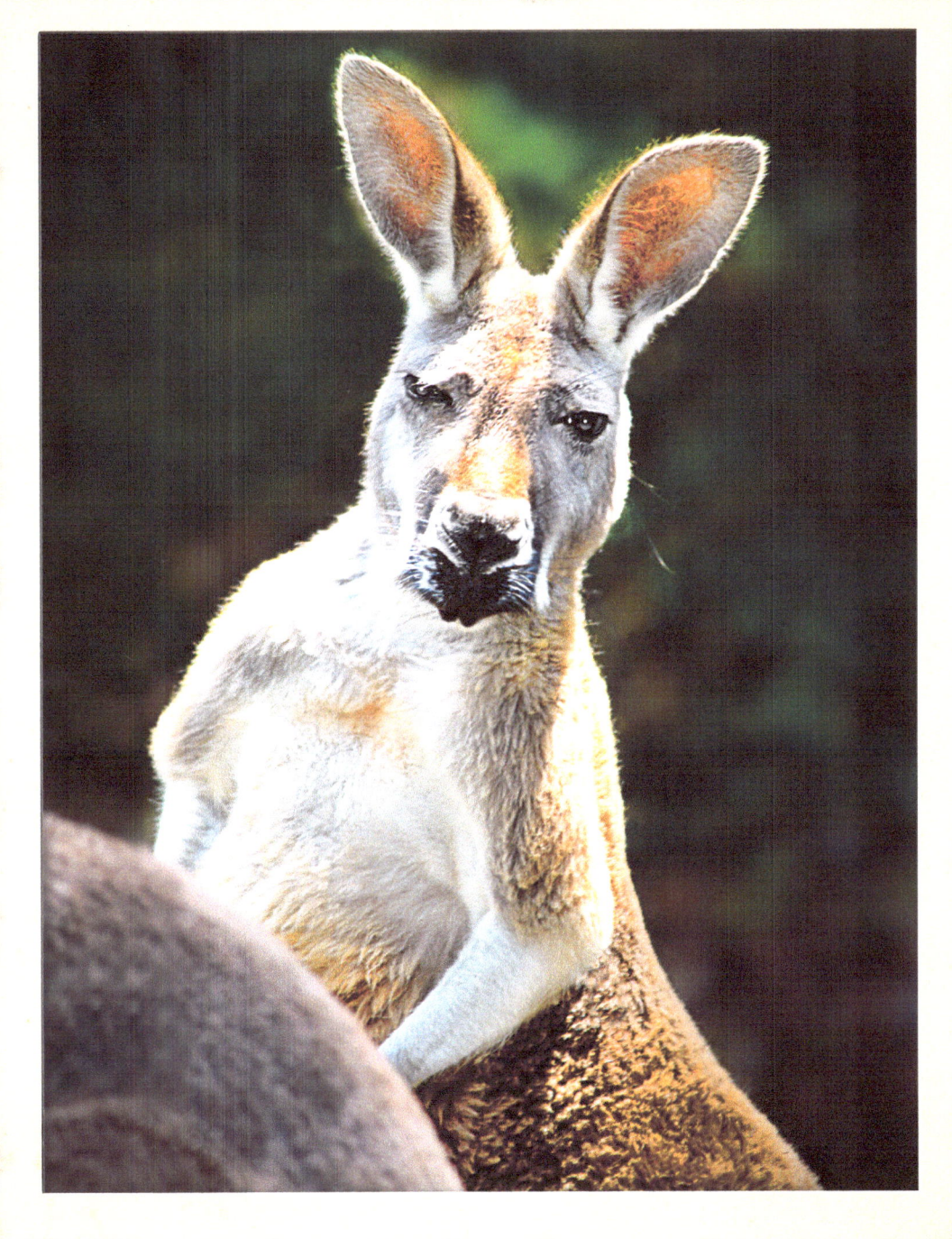

You, looking at ME?

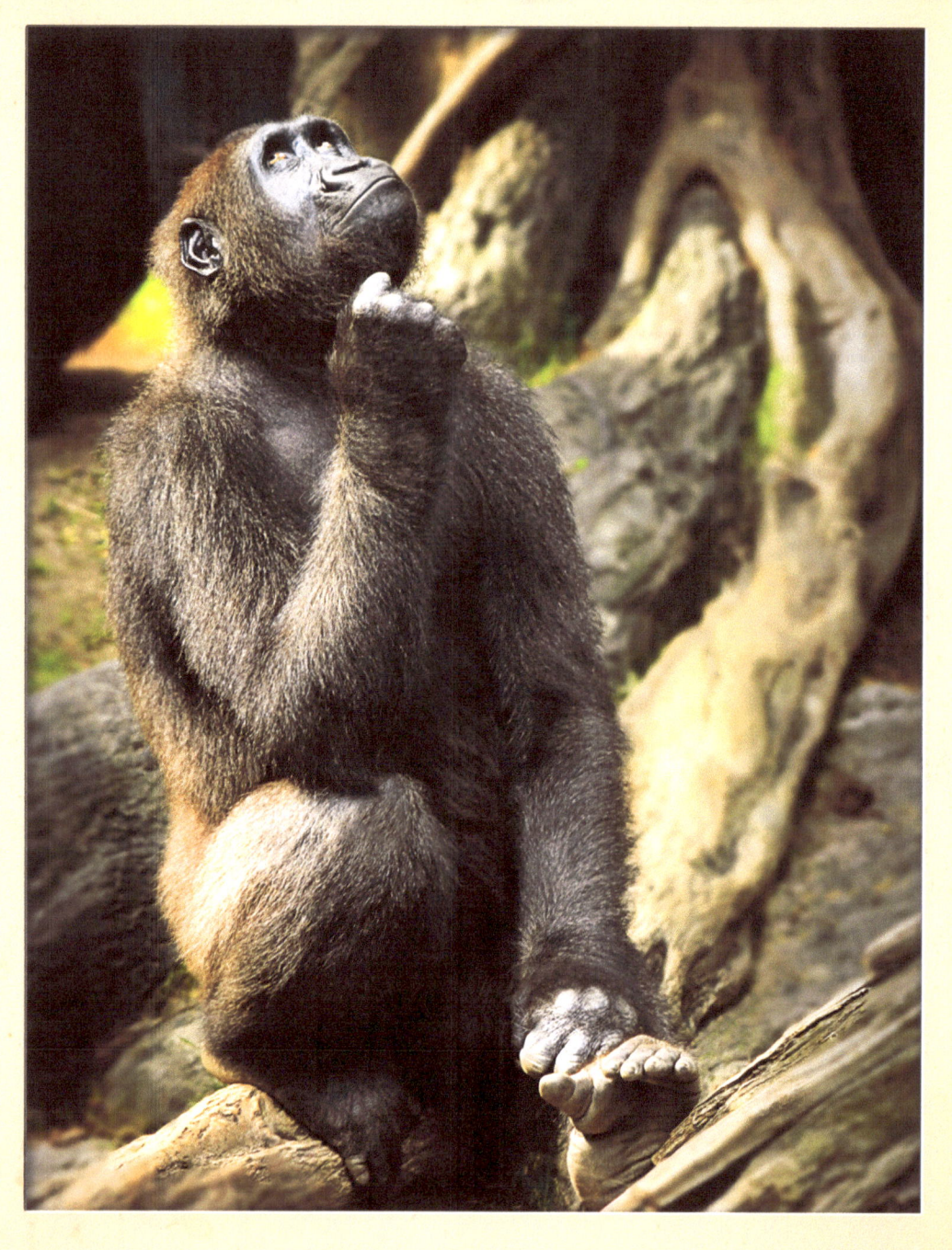

Is that Ms. 'Lush Tush' showing off on that branch again?...

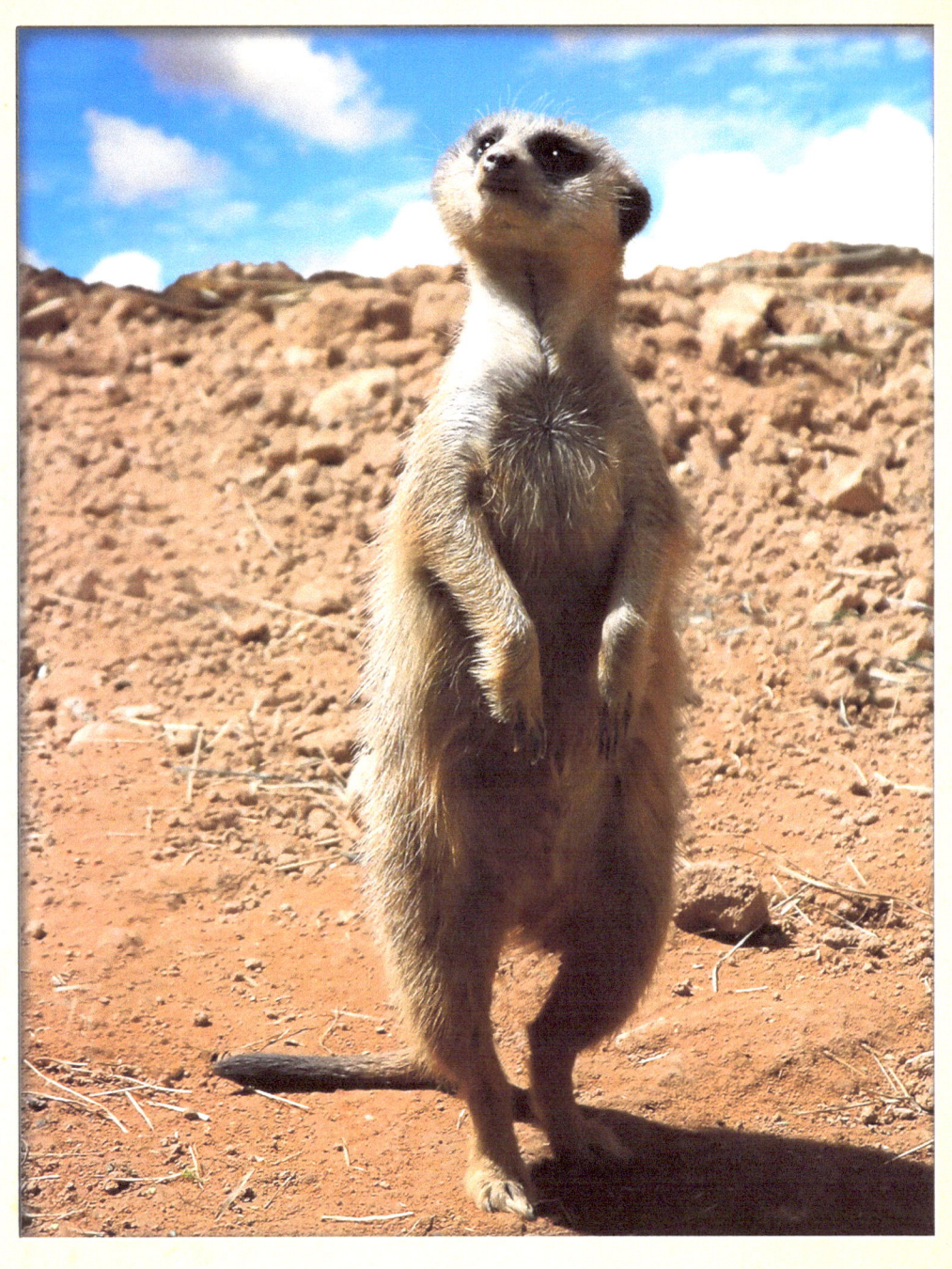

On the count of three, everyone, Plié!!...

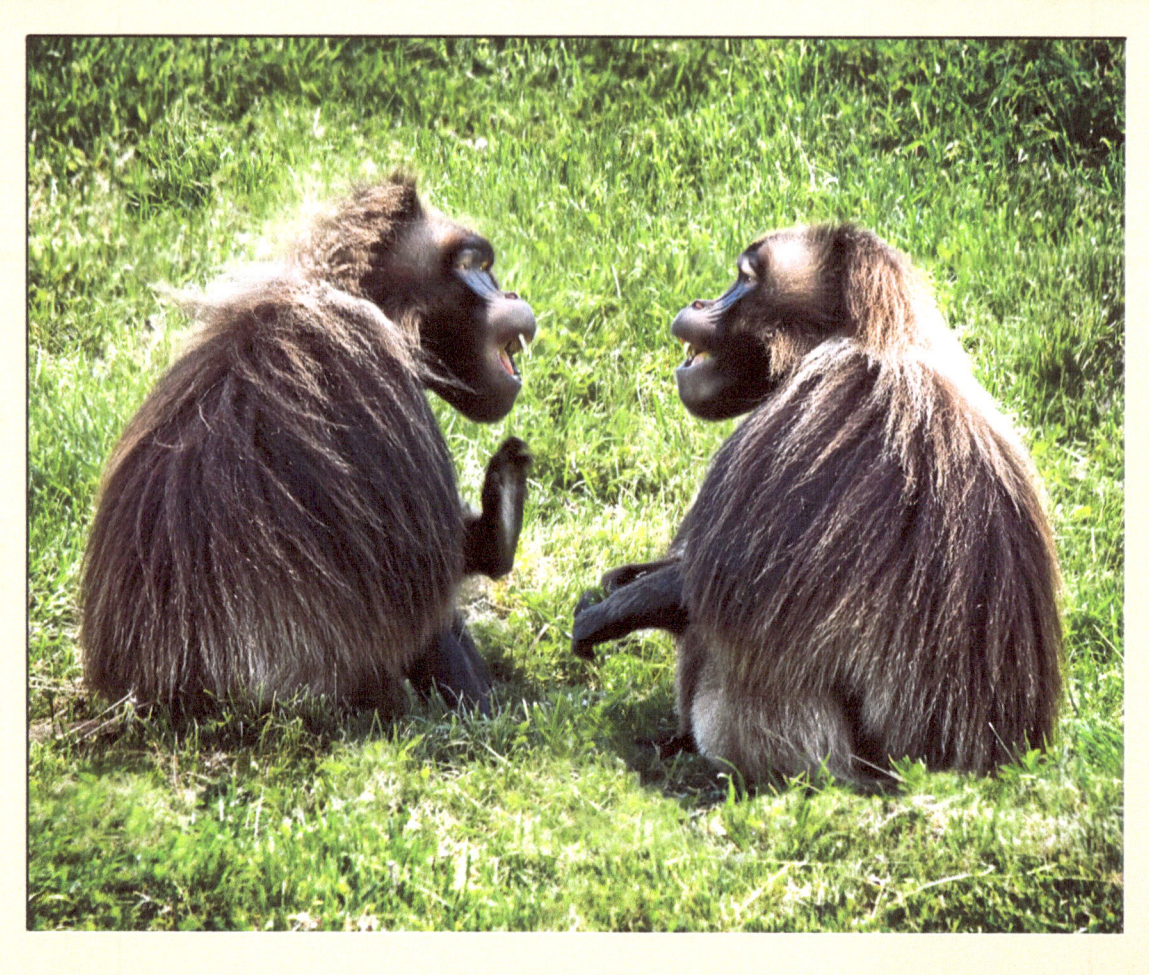

Talk to the hand,
Blanche,
talk to the hand...

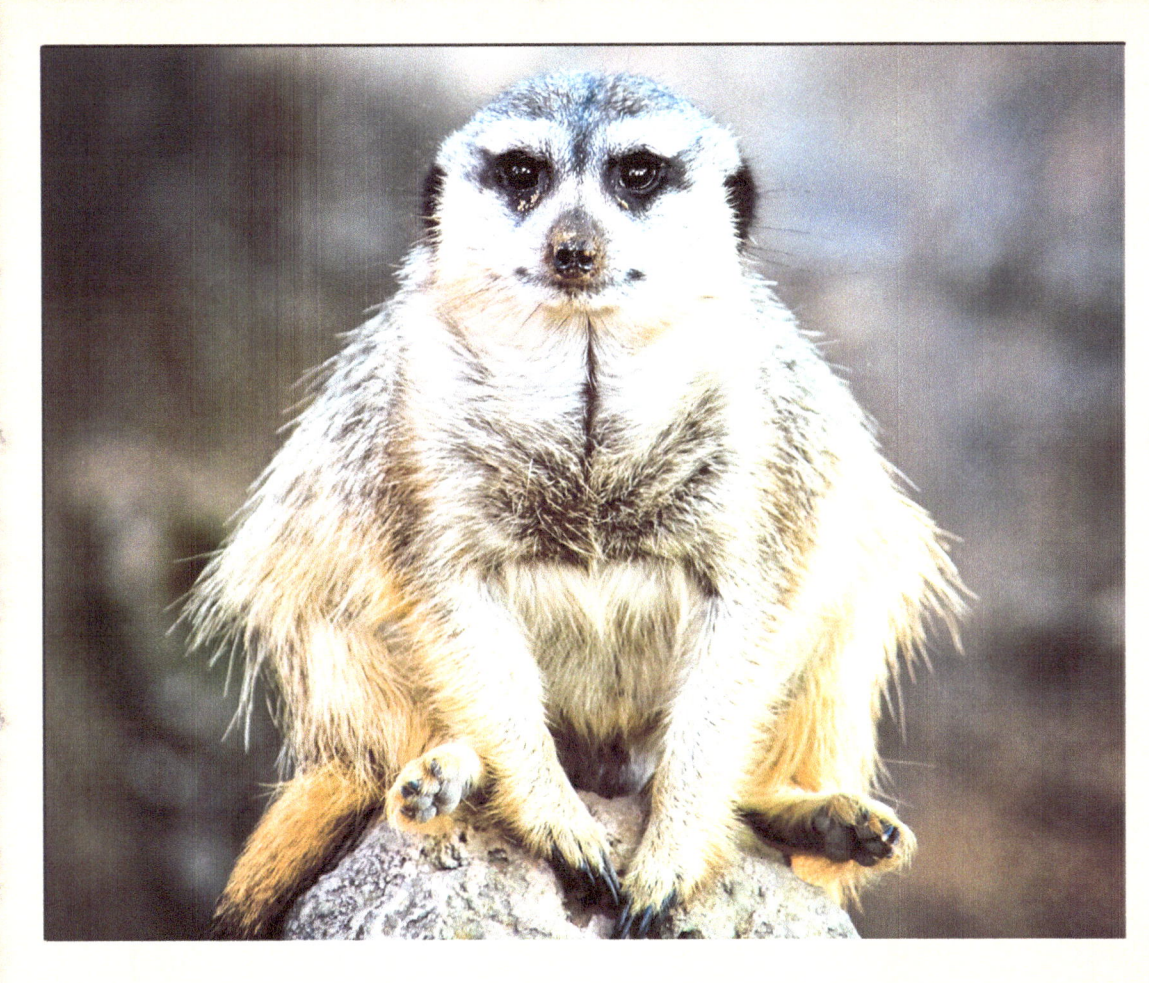

Who, me? I'm happy just sitting on a rock...

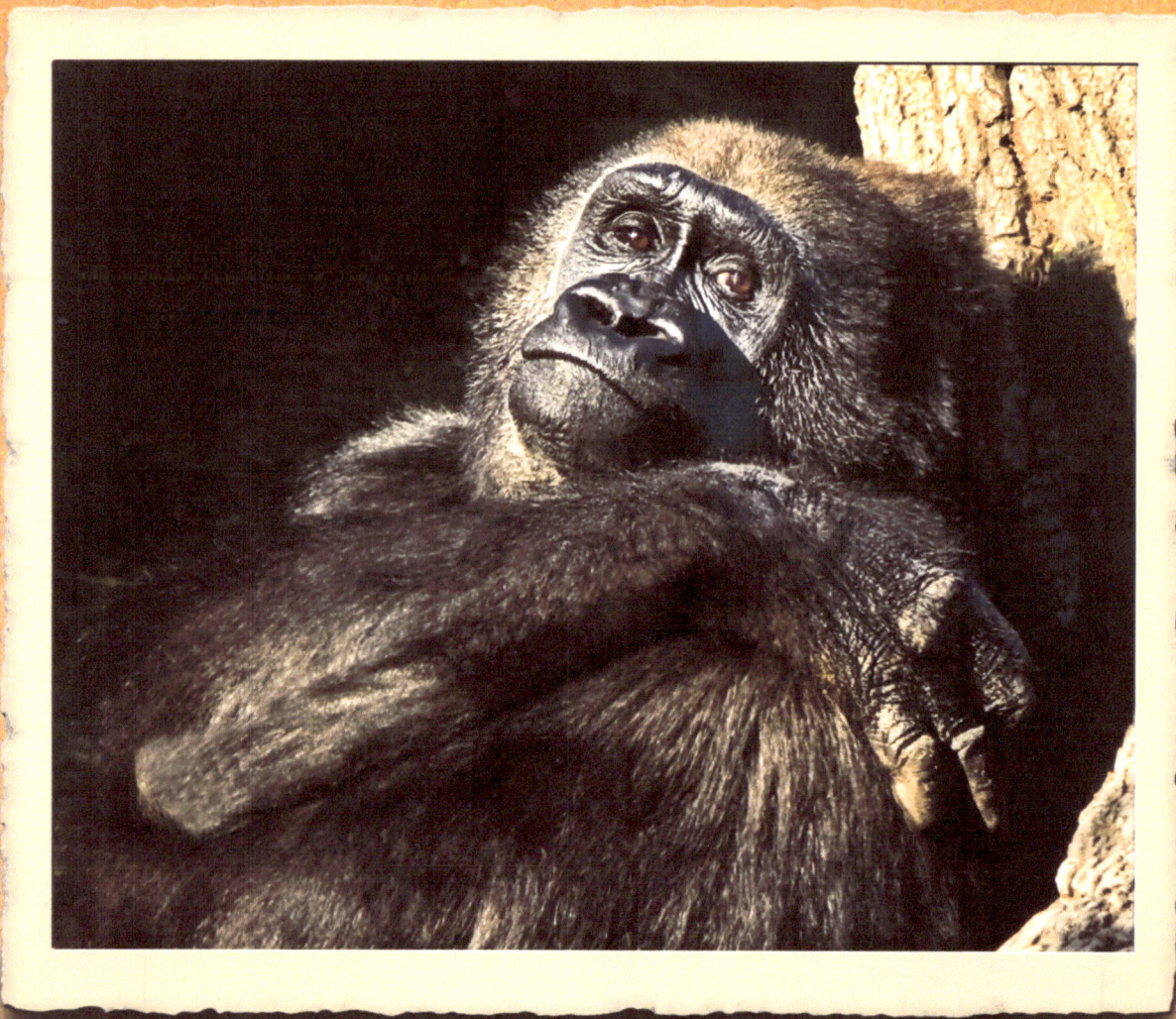

Gorilla Ennui...

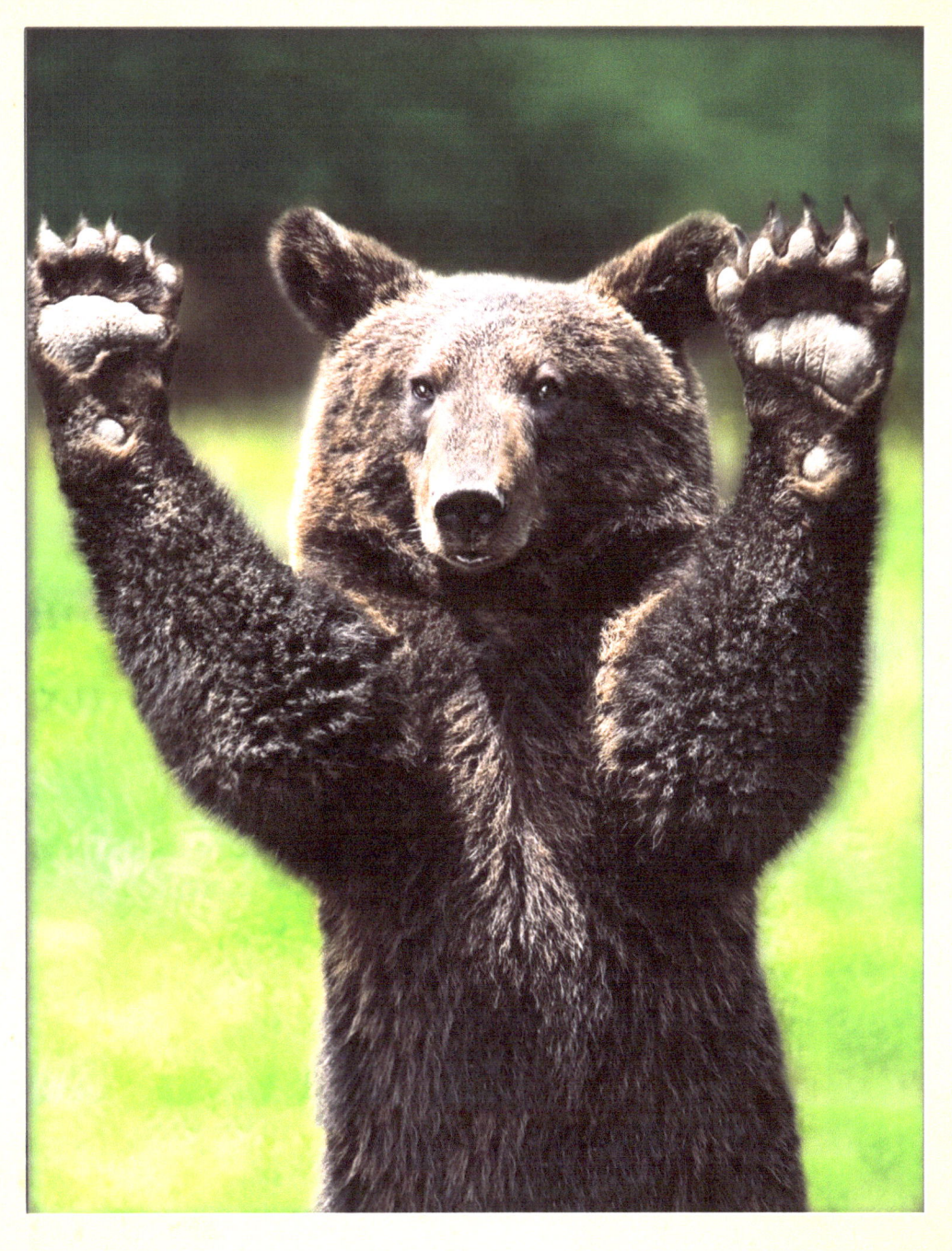

I surrender Officer, what took you so long?

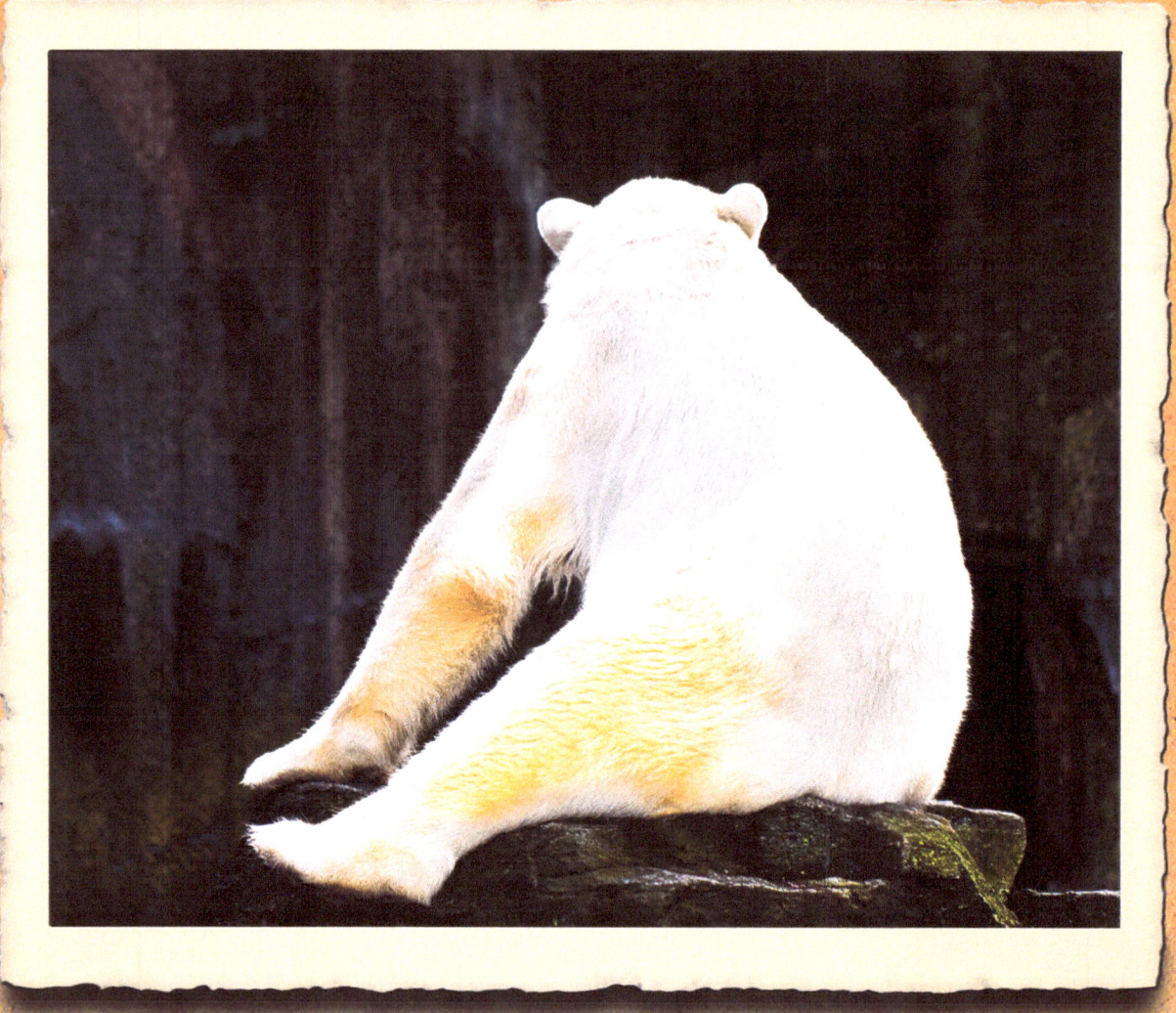

I refuse, simply refuse to pose until I get hair and make-up...

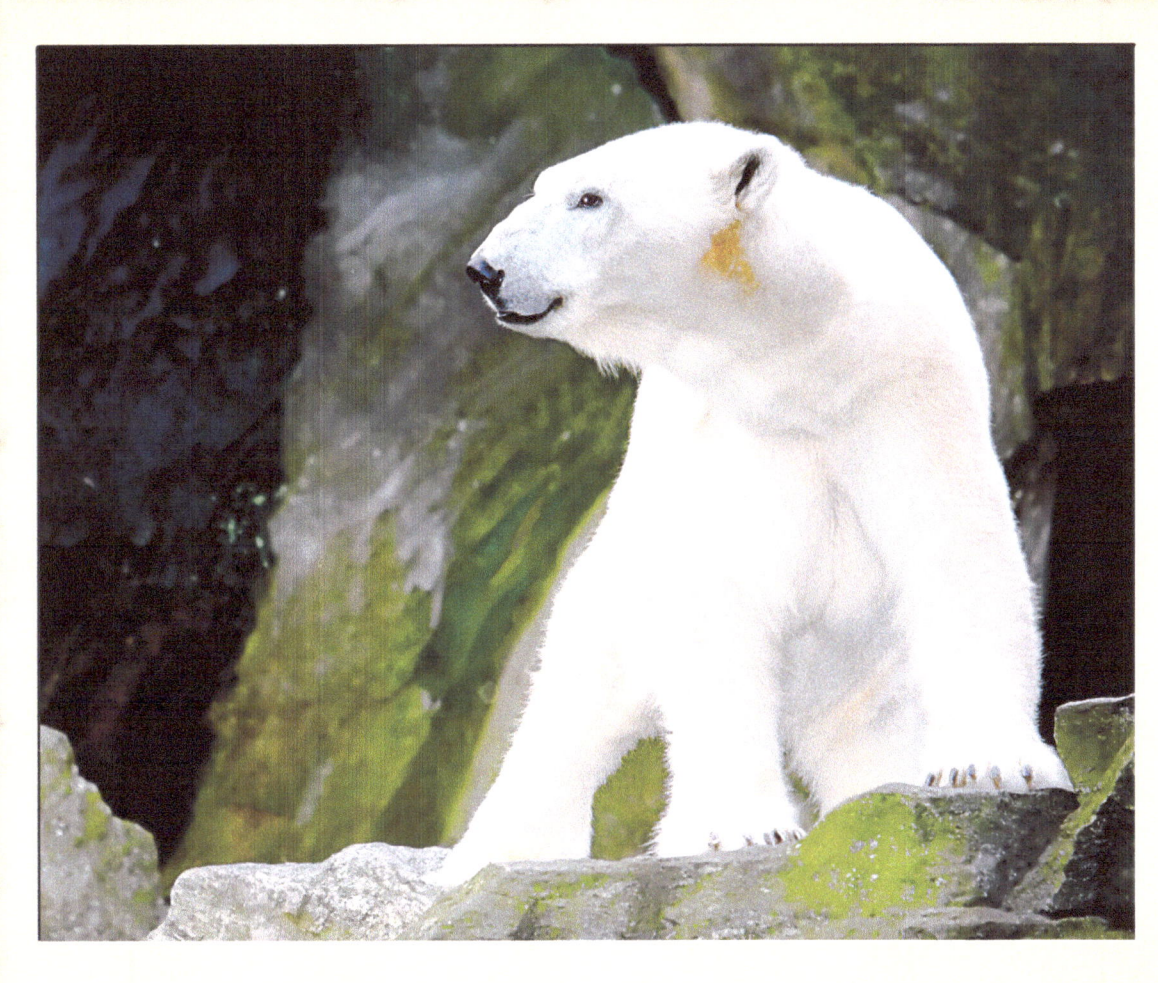

Now, don't I cut a dashing profile, mmm?

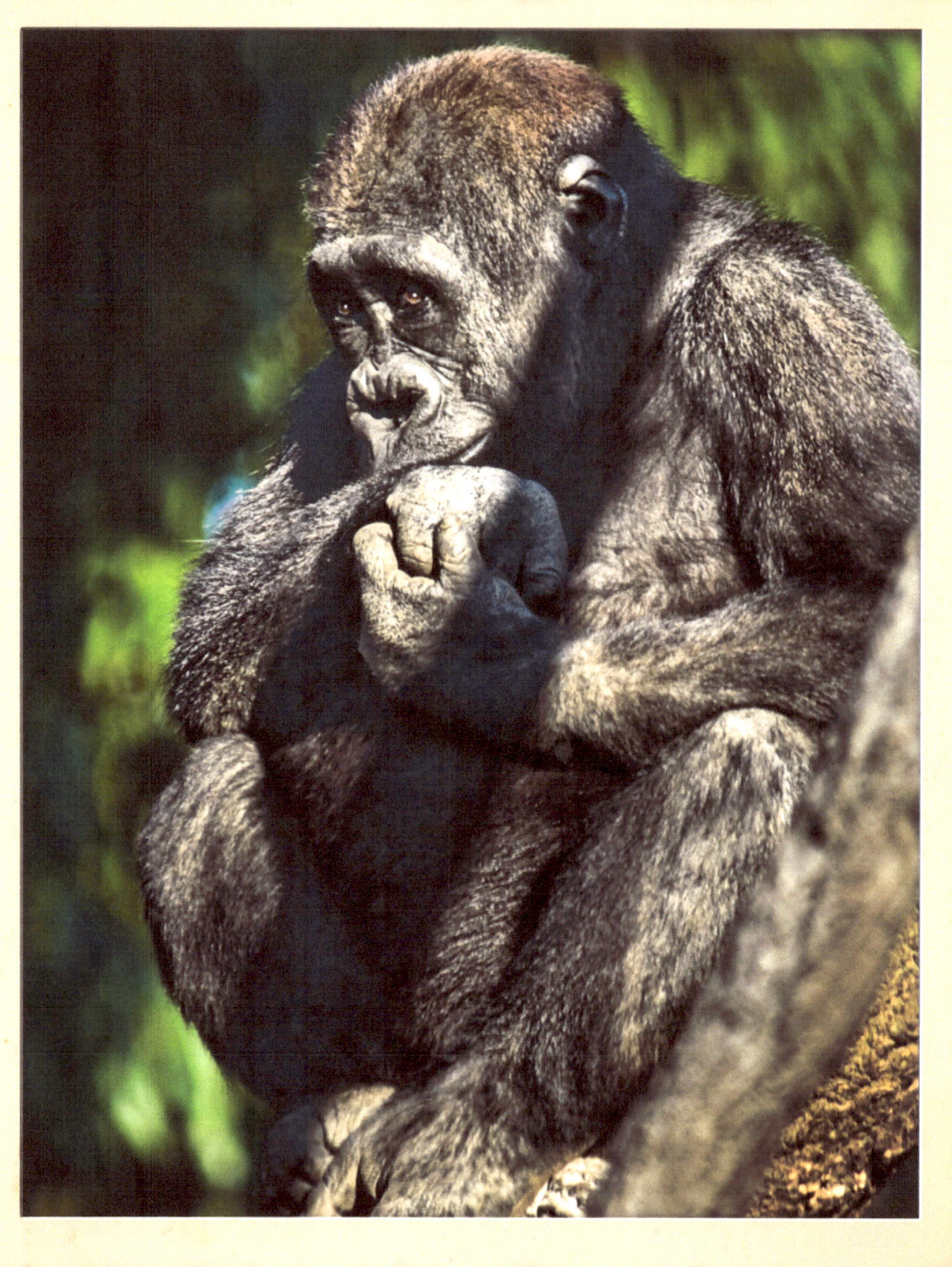

Oh, Criminy, I hear the Alpha Male wants to see me after brunch...

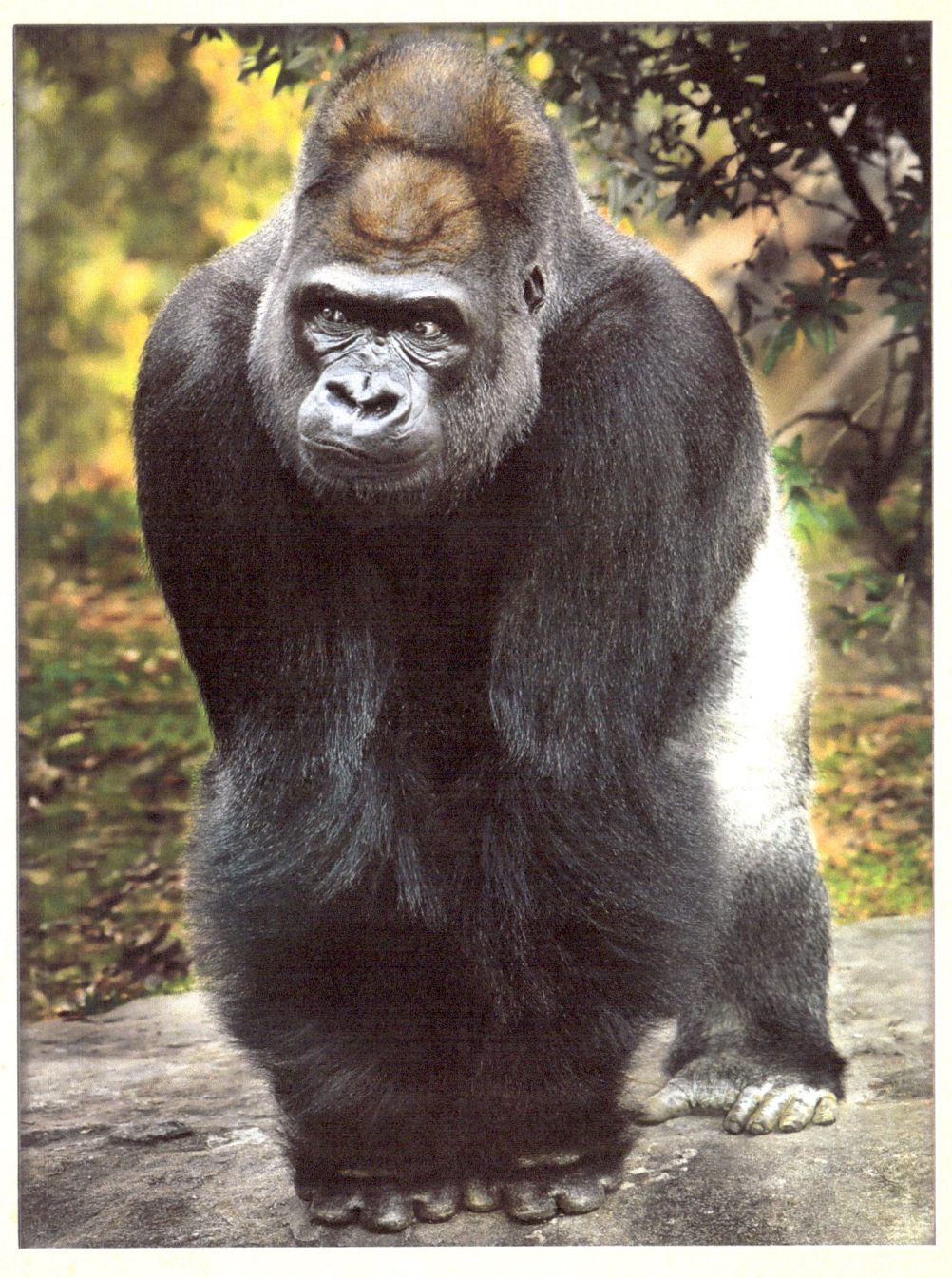

Kids these days!!!
With their new-fangled
sticks and stones...

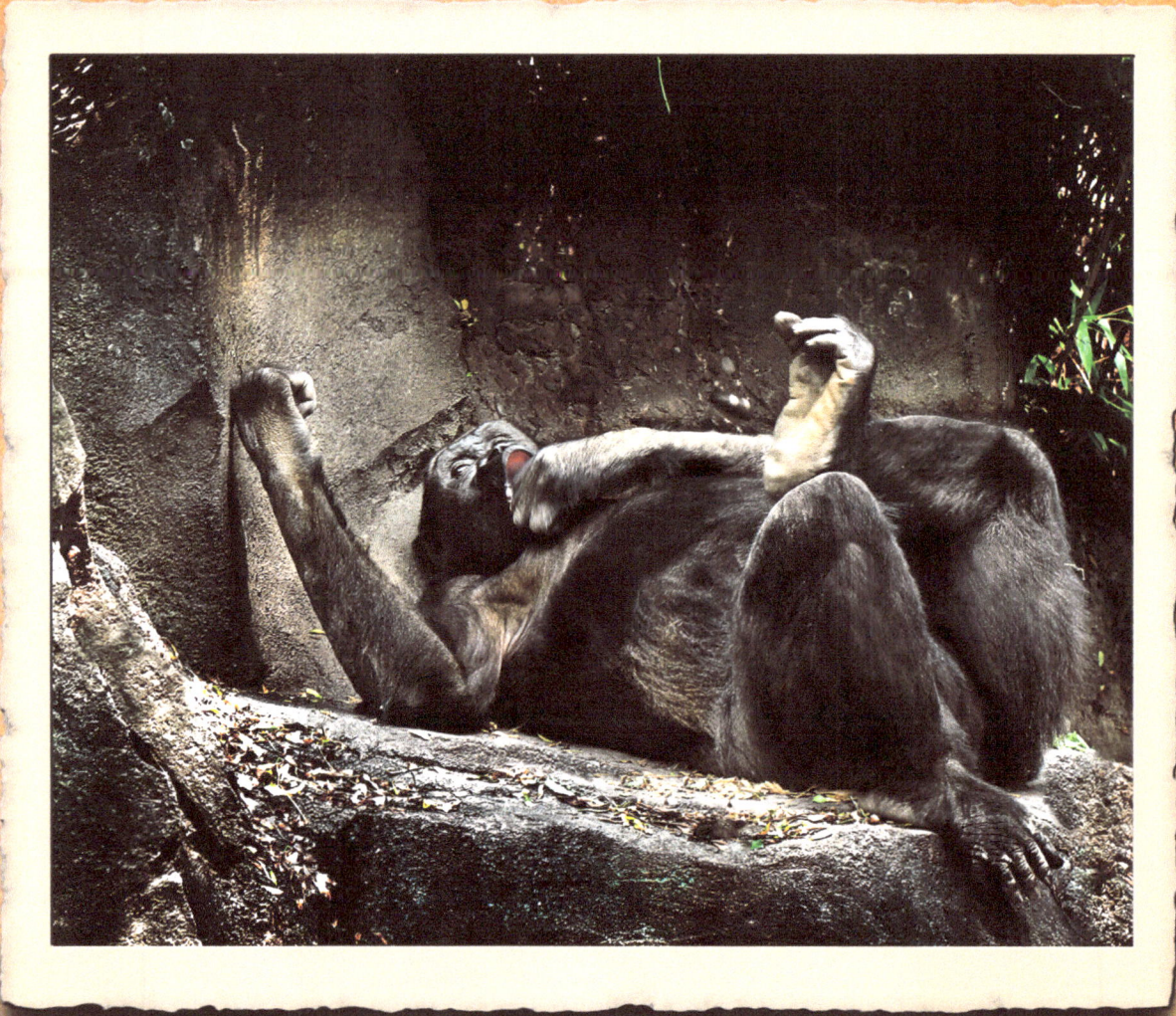

Jungle Riff-Raff

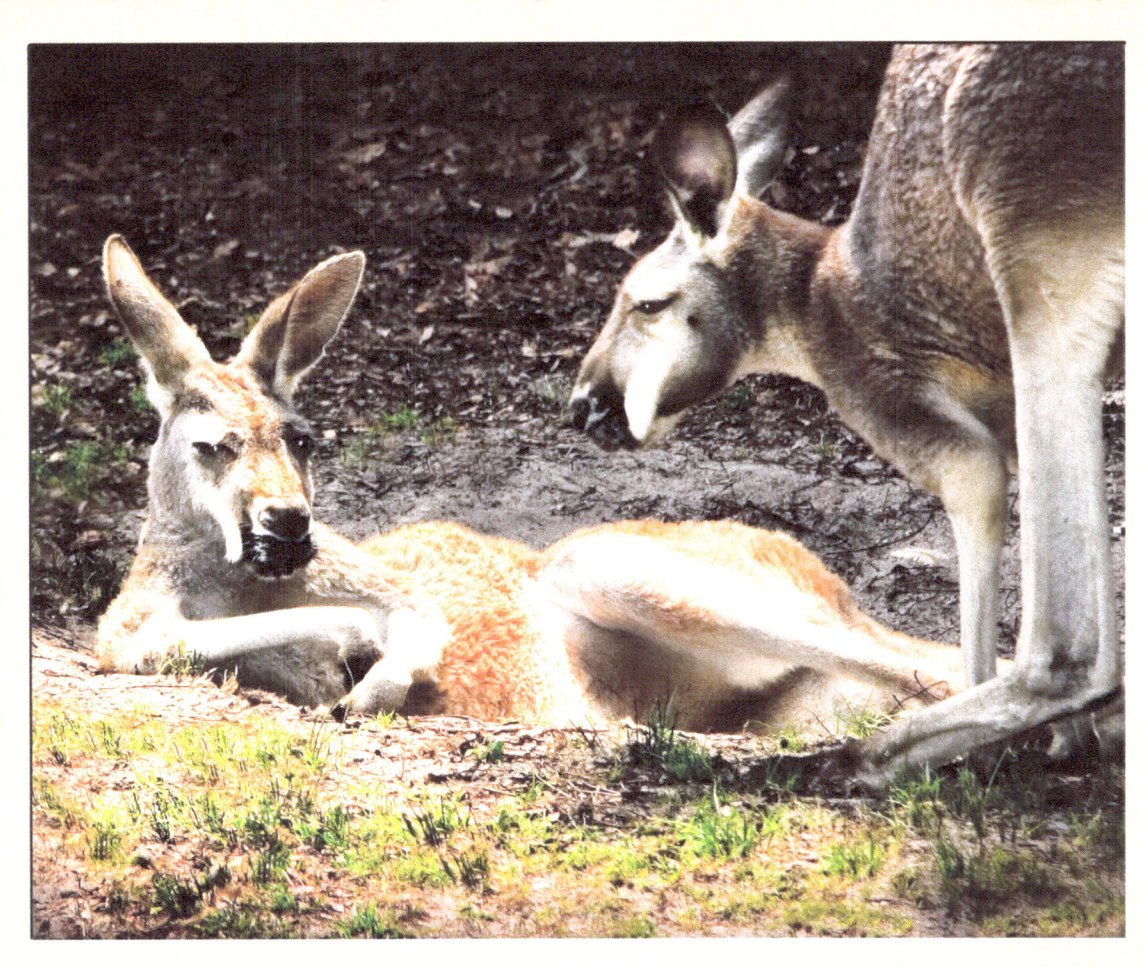

Y'know mate, I'm still skeptical of this so-called Zoo arrangement deal...

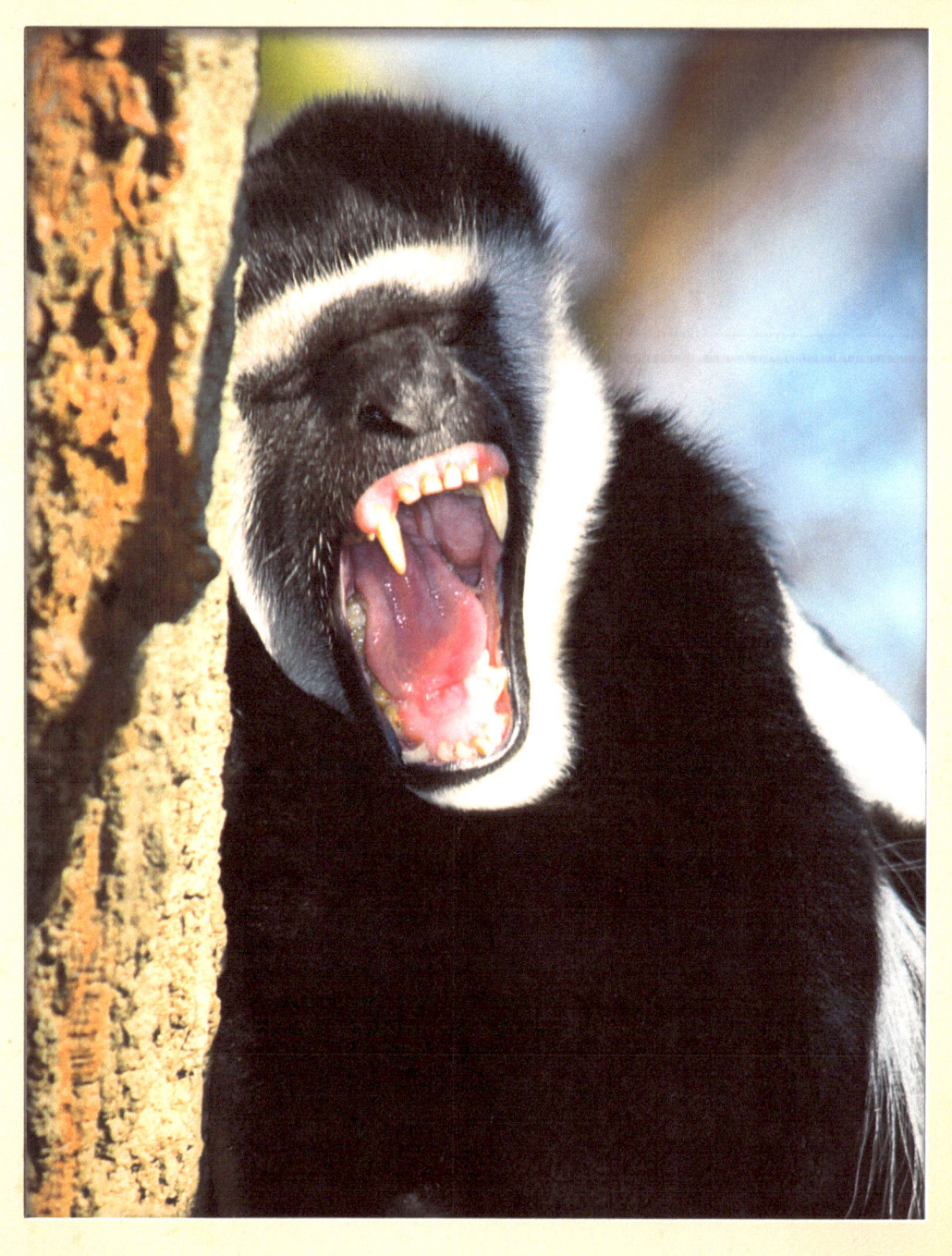

Don't tell Verne about his morning breath, he won't take it well...

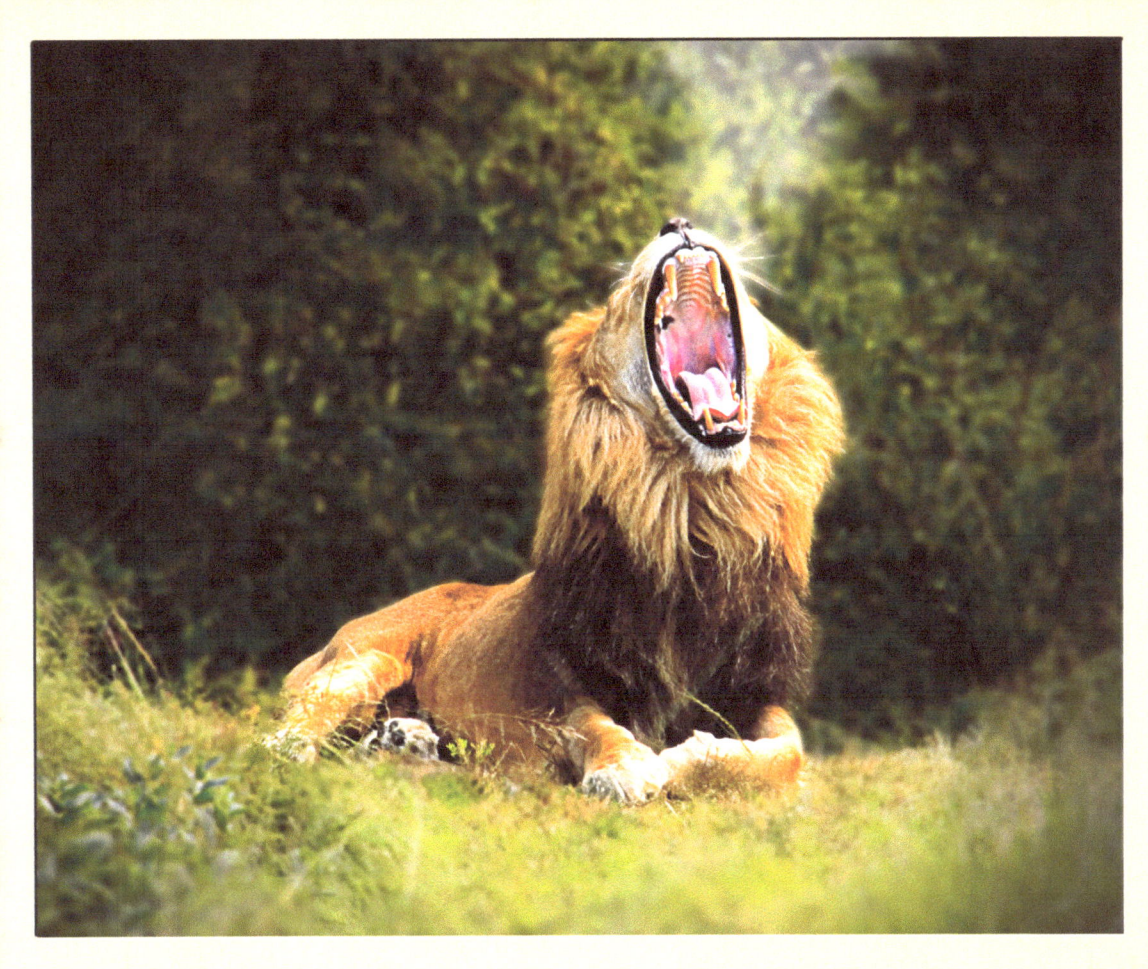

It's good
to be The King...

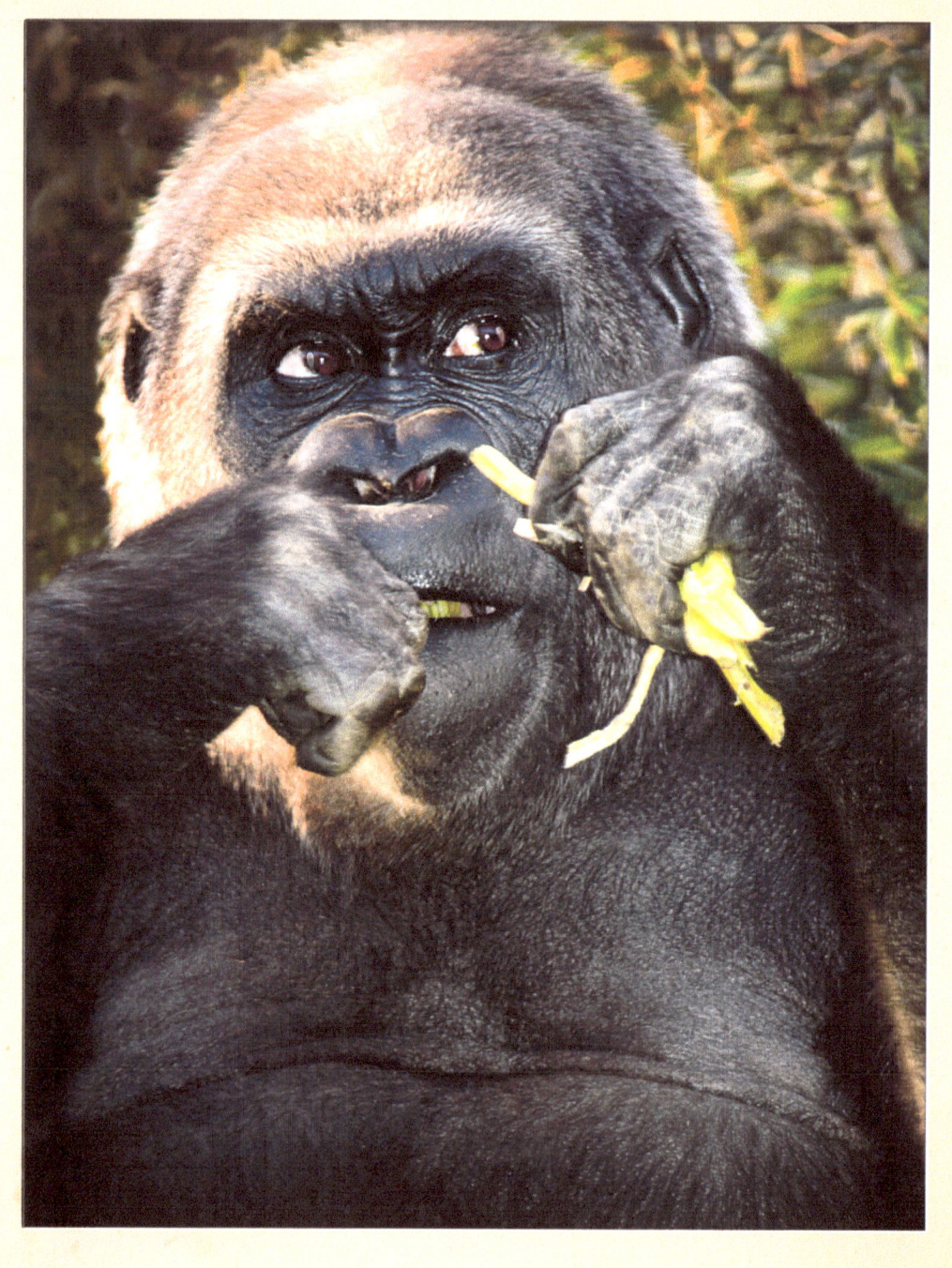

I didn't fight my way to be the top Alpha male in this here Zoo, just to be a vegetarian, y'know...

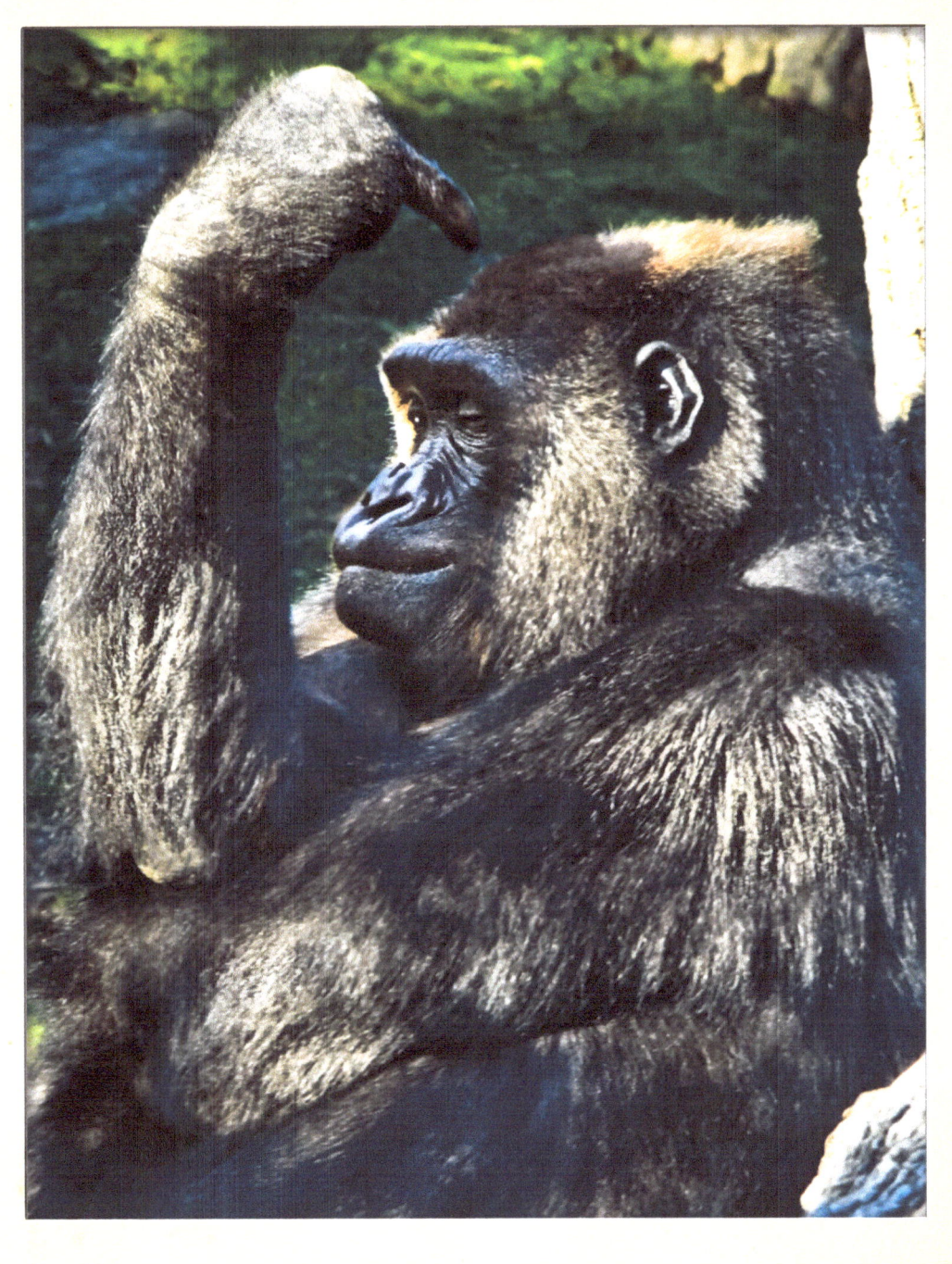

I Stink, therefore, I am...

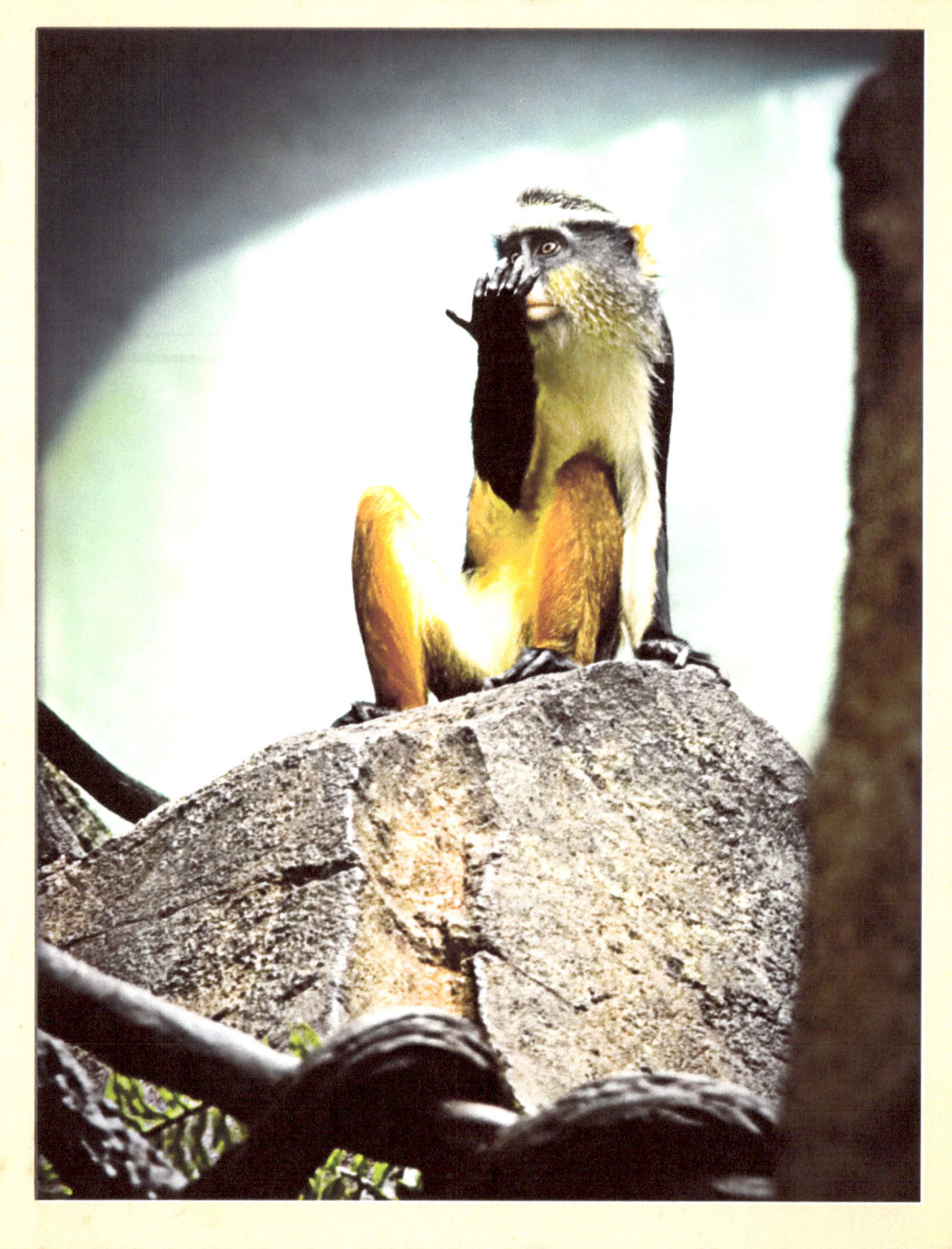

Did I just sit on what I "sniff" think I sat on?...

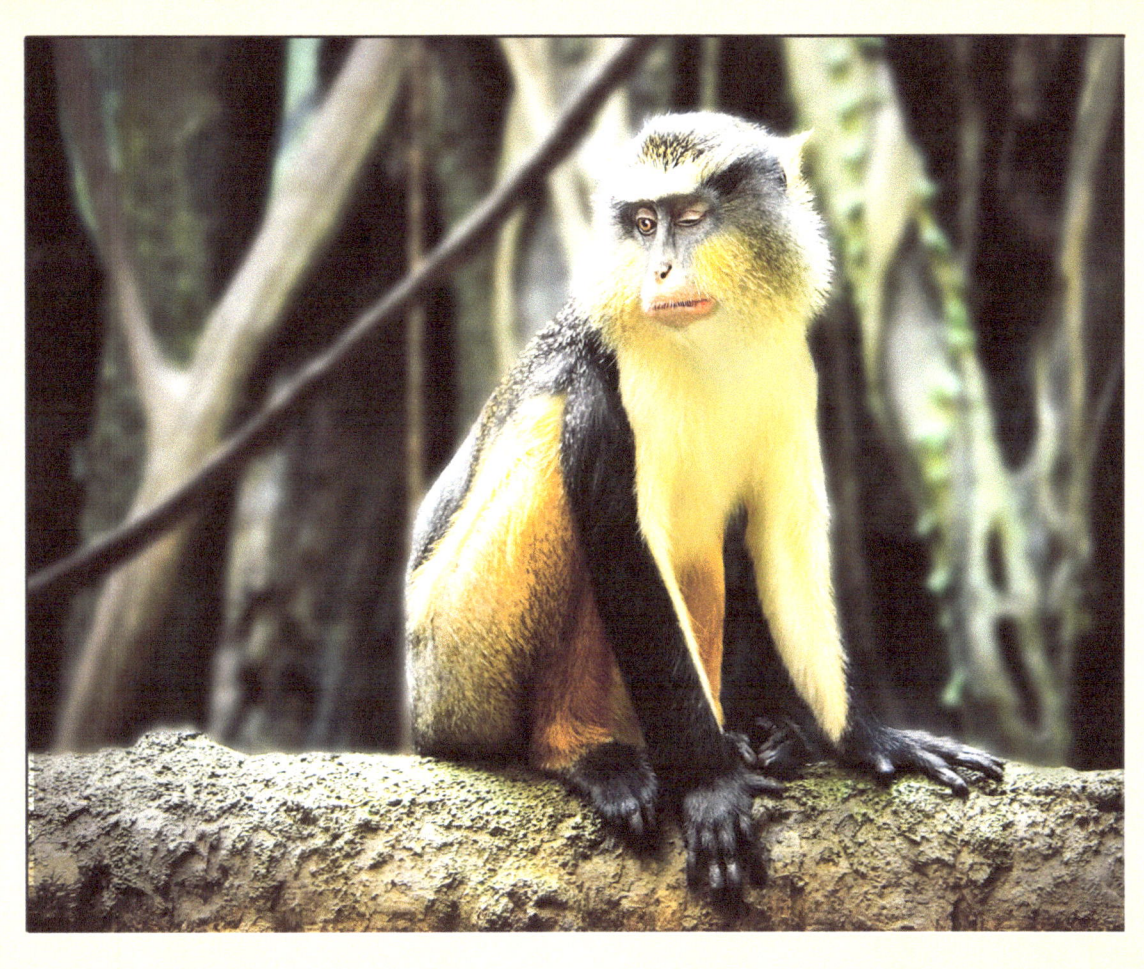

Aaach! I think I just swallowed a bug!...

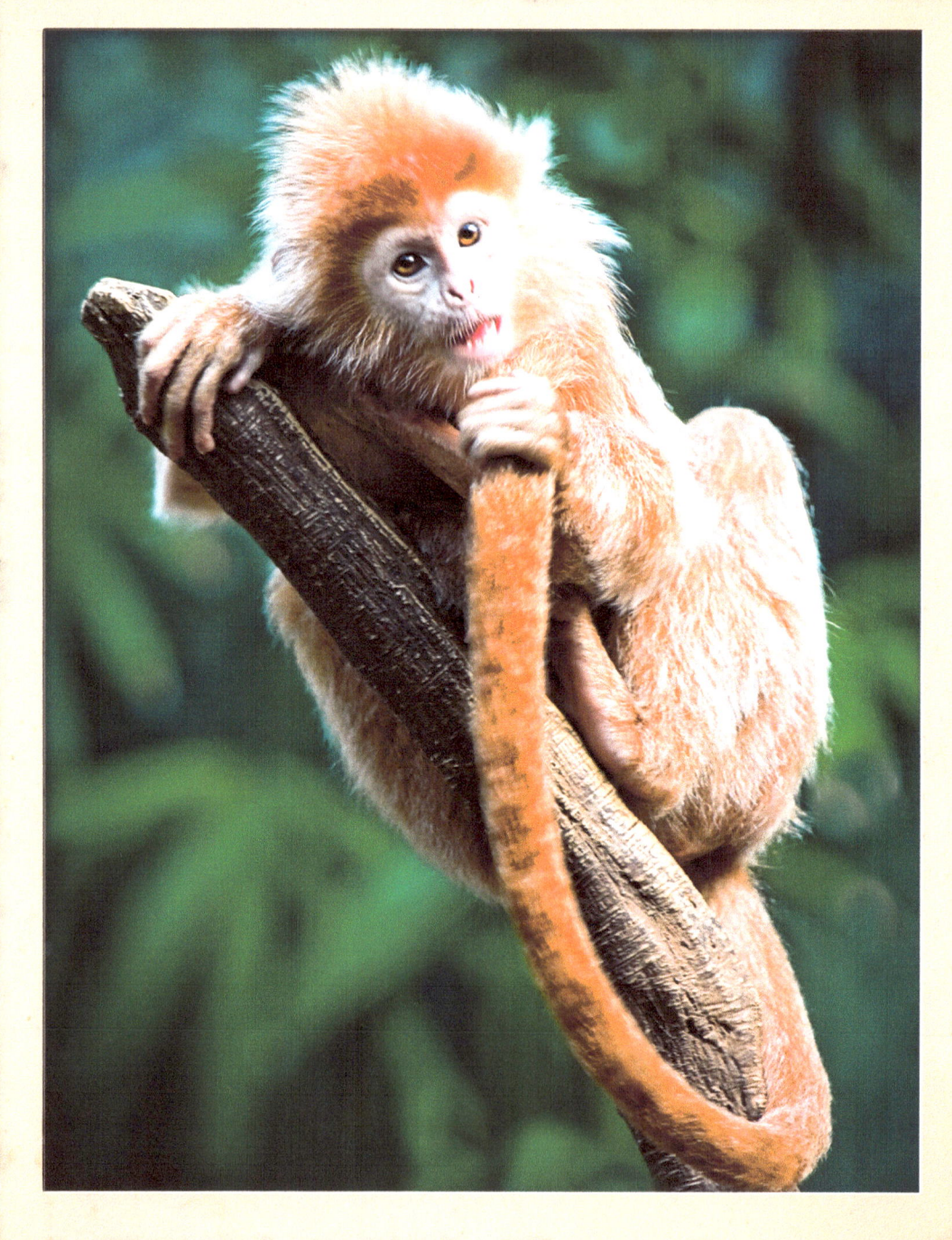

Jungle Karaoke now, testing, testing 1, 2, 3...

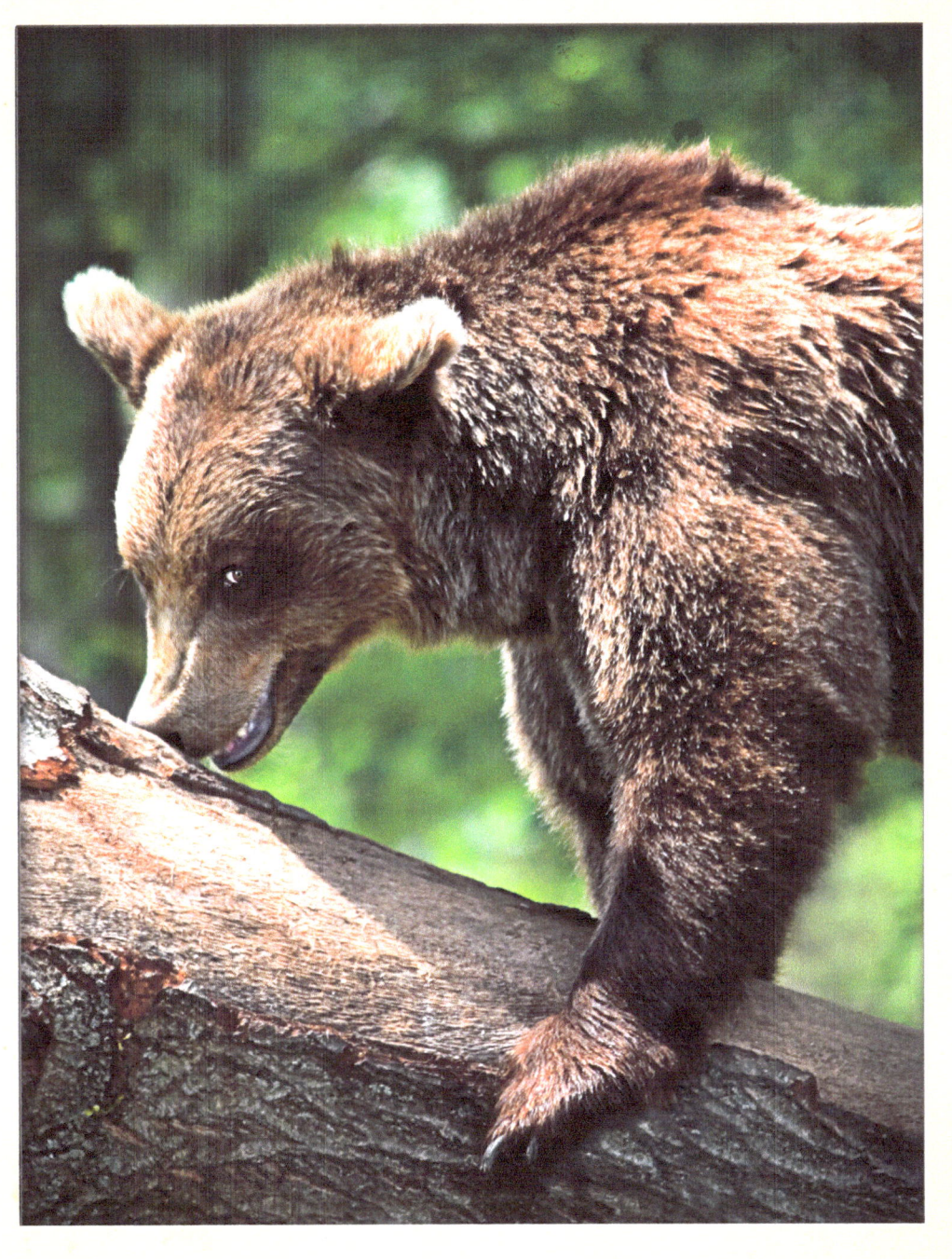

C'mon, if you come a little closer you'll get a better picture...

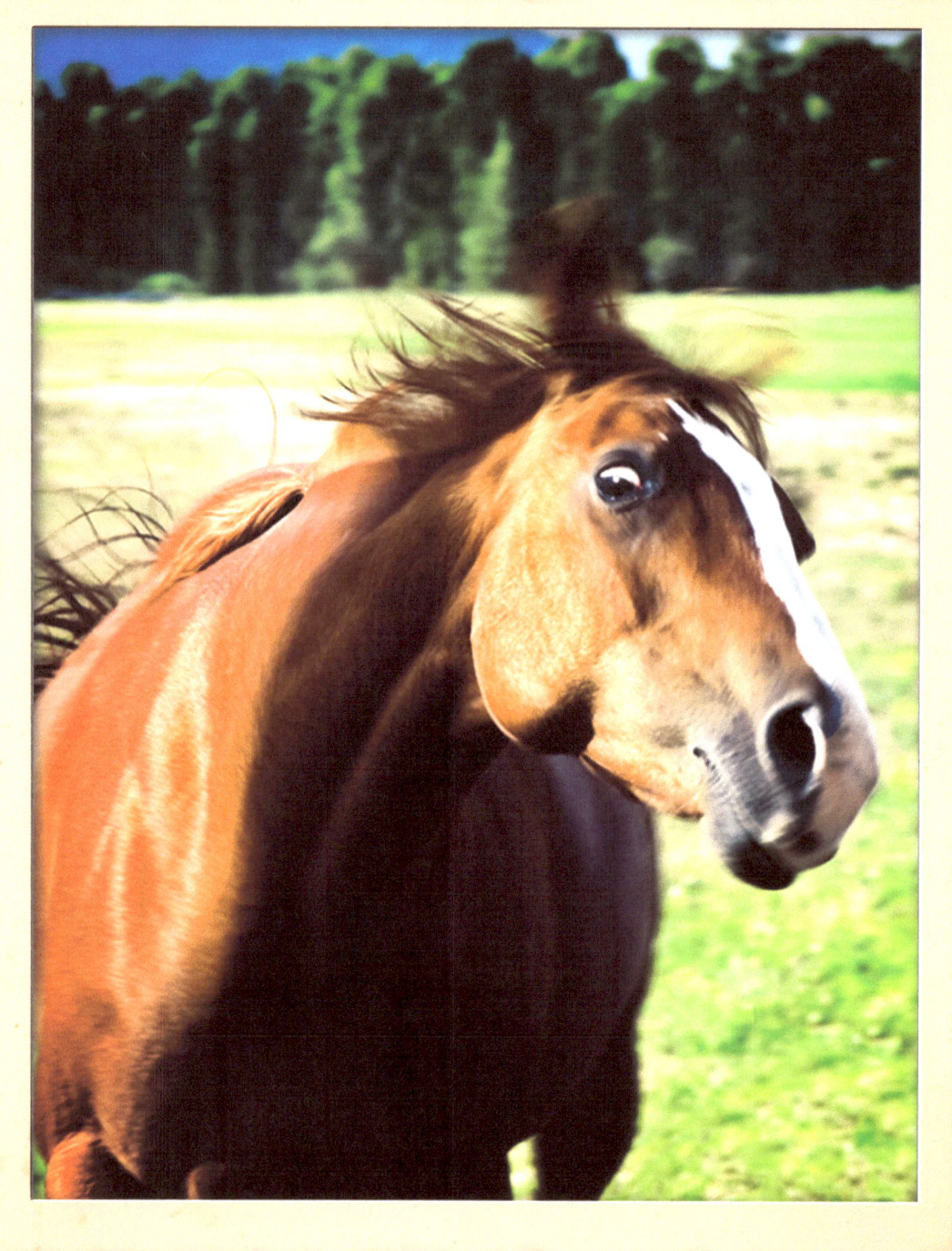

Whaddaya mean what's with the long face?..

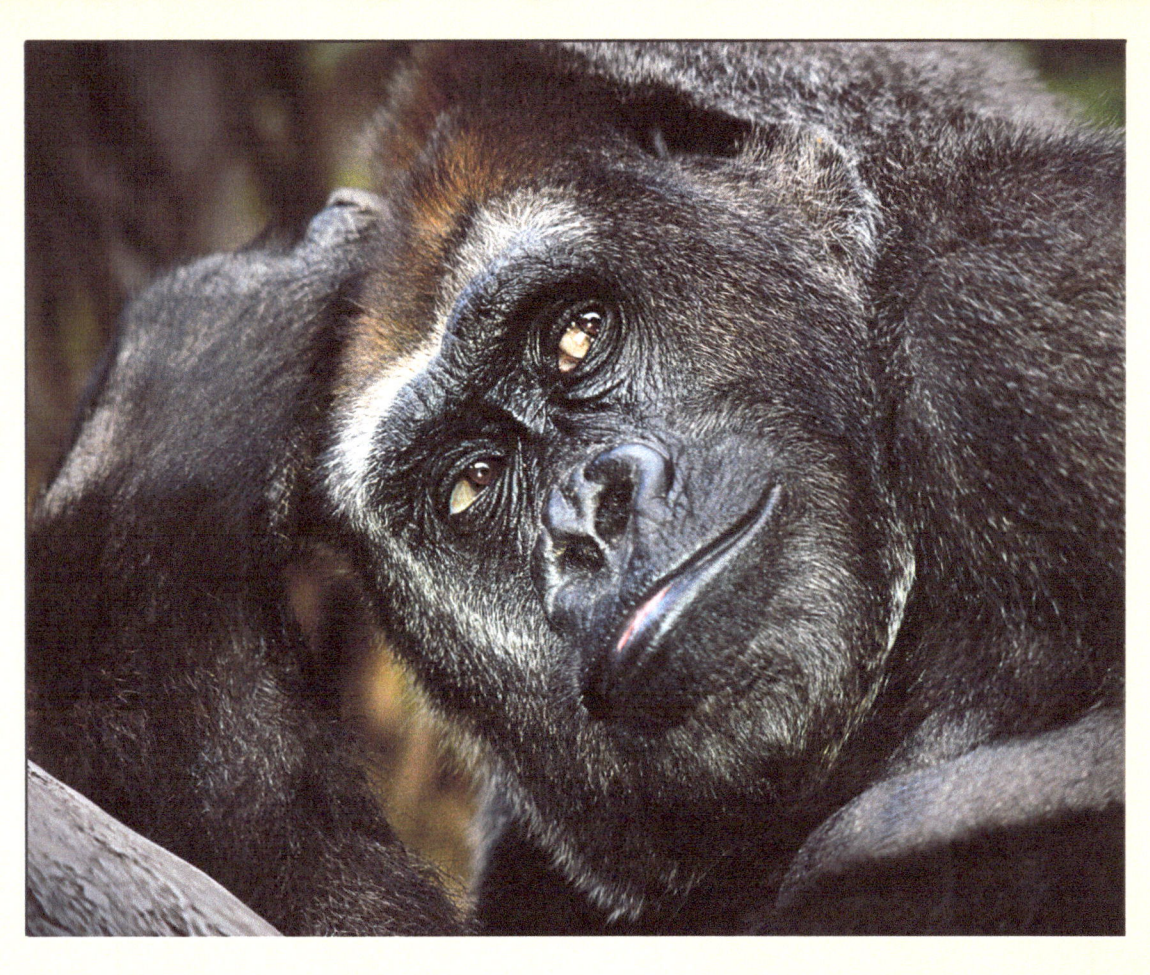

Allright Mr. DeMille, I'm ready for my Close-up...

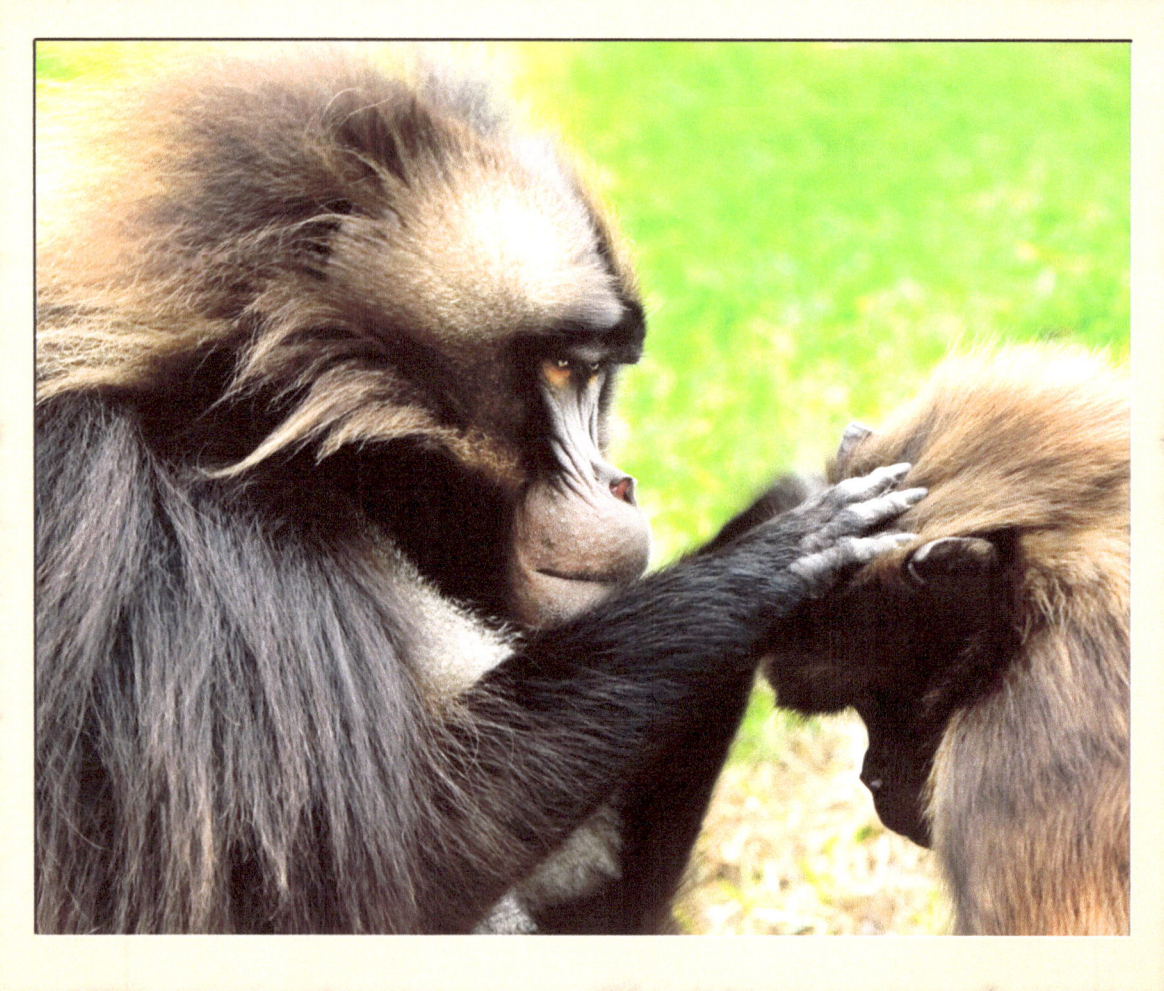

Quit squirmin' around will ya, I'm trying to find a snack...

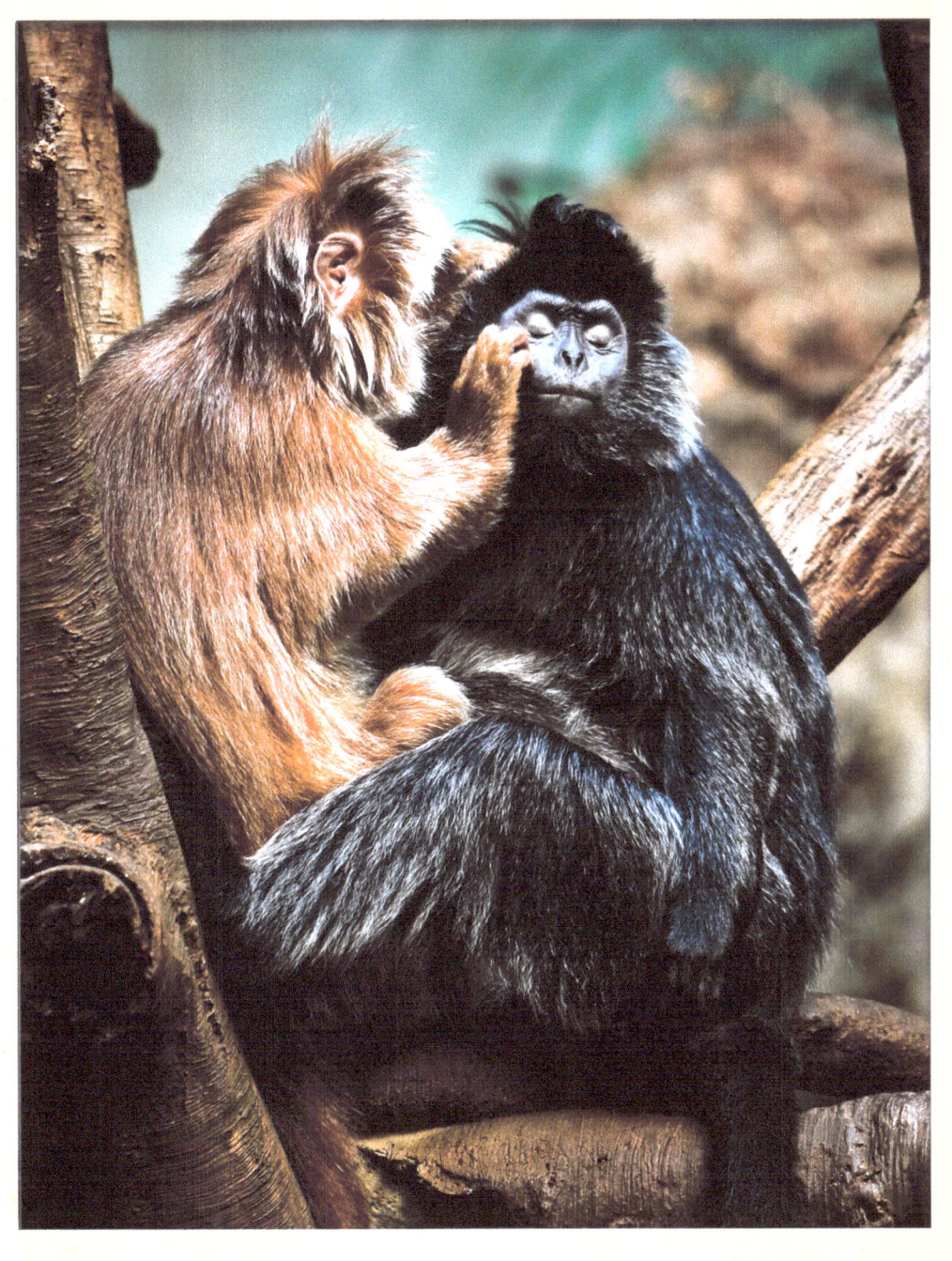

Not too heavy on the mascara, Elvira...

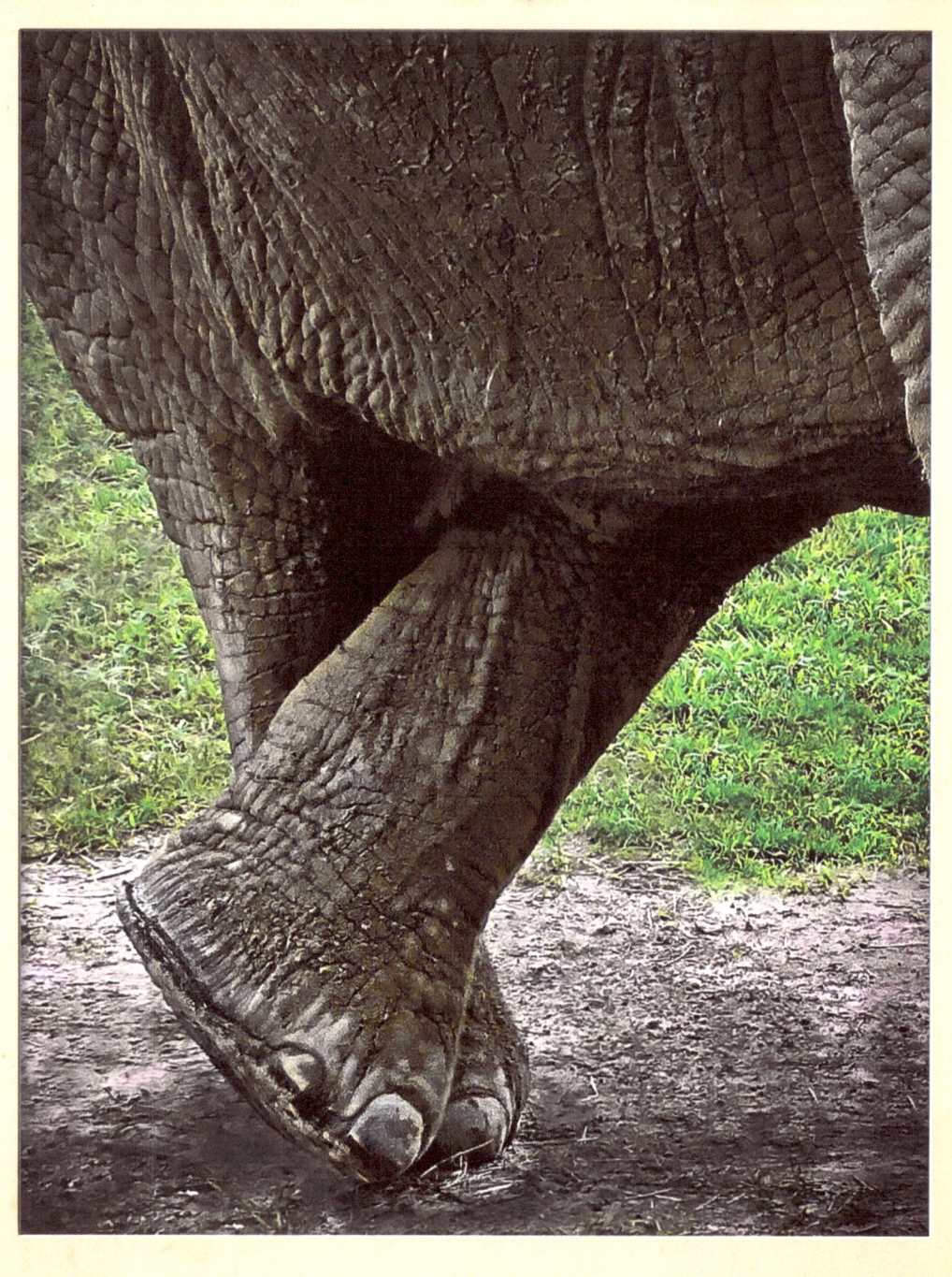

May I go now, pleeez??...

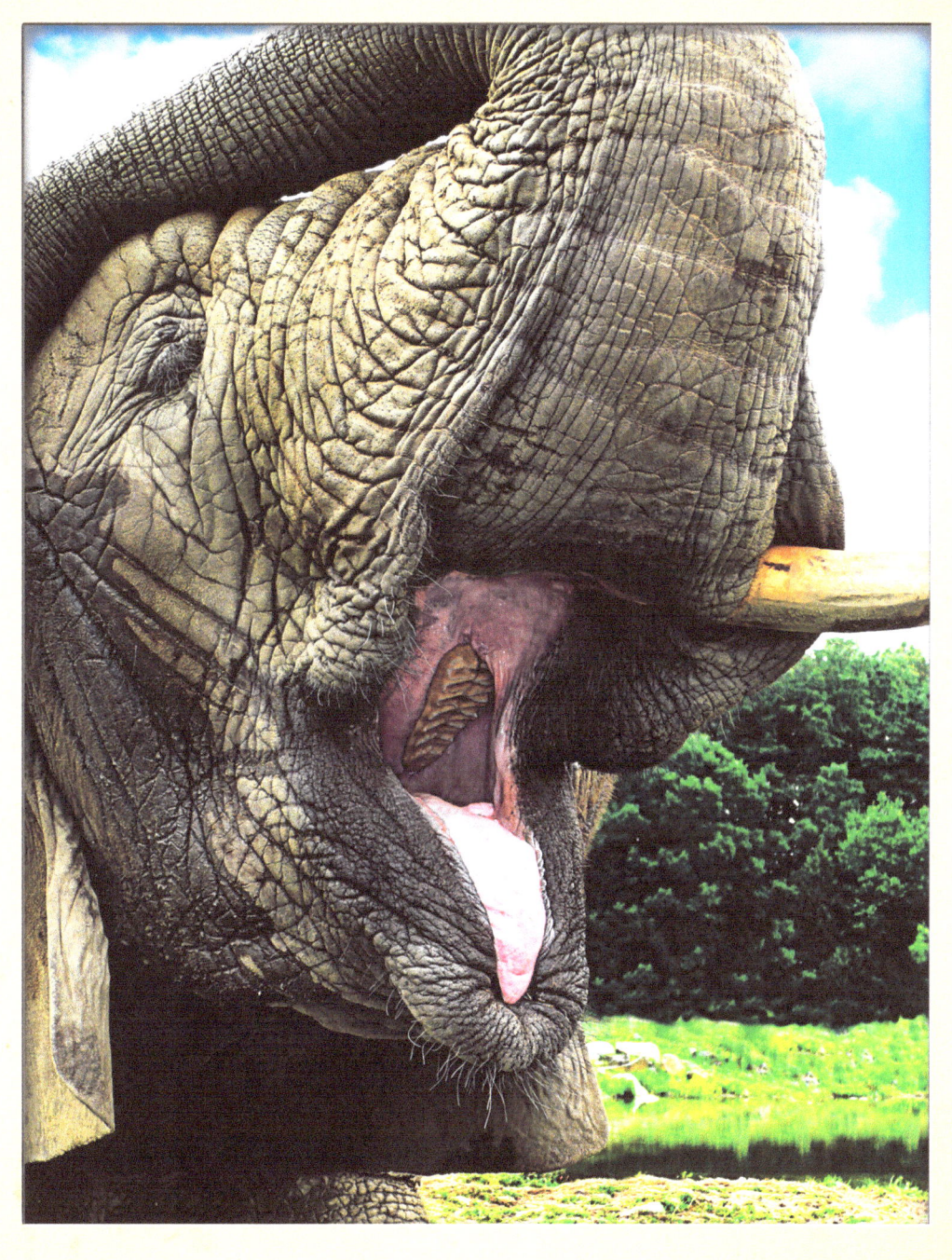

Look Ma, no cavities!!...

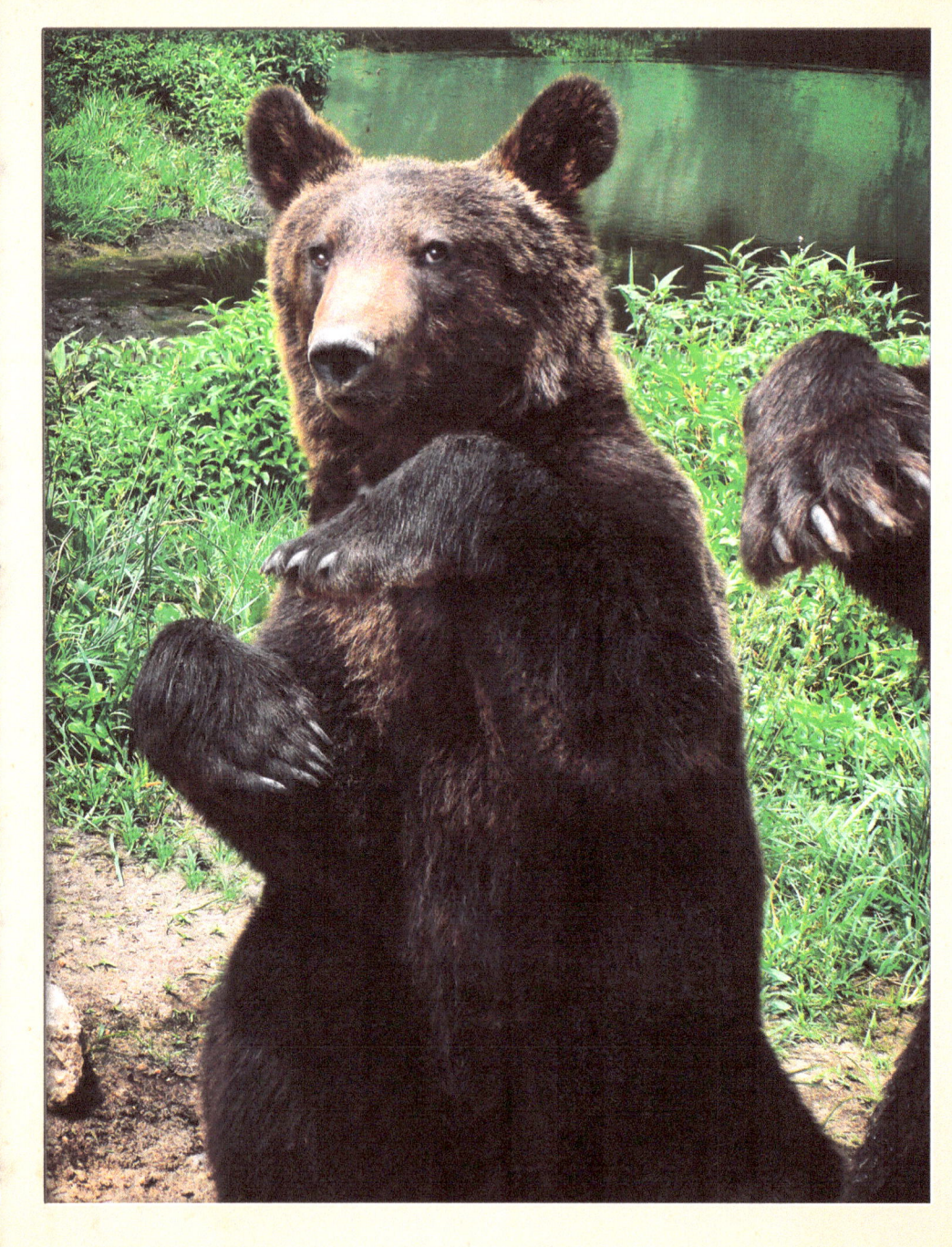

Rappin' Bears

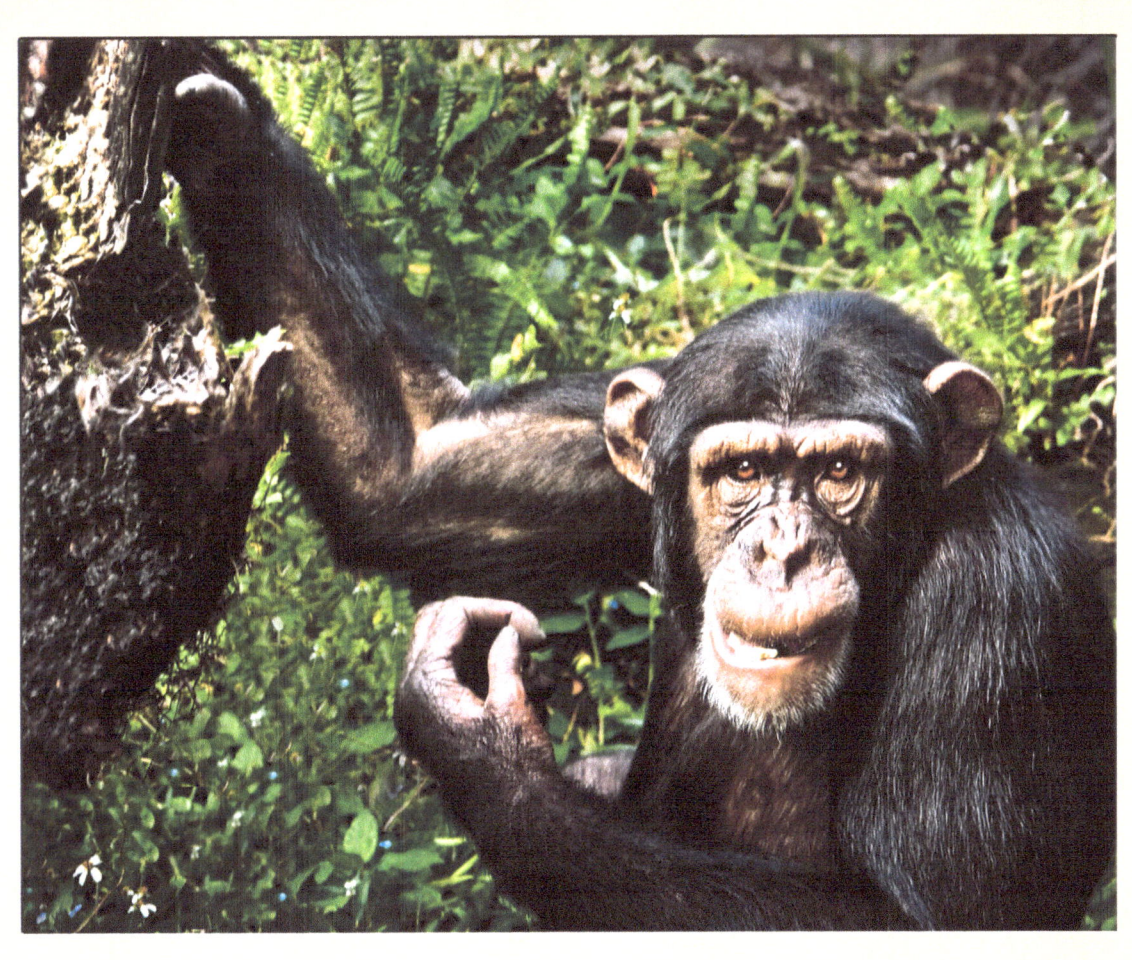

And now, ladies & gents, I give you... the new & improved Termite Incubatorr...

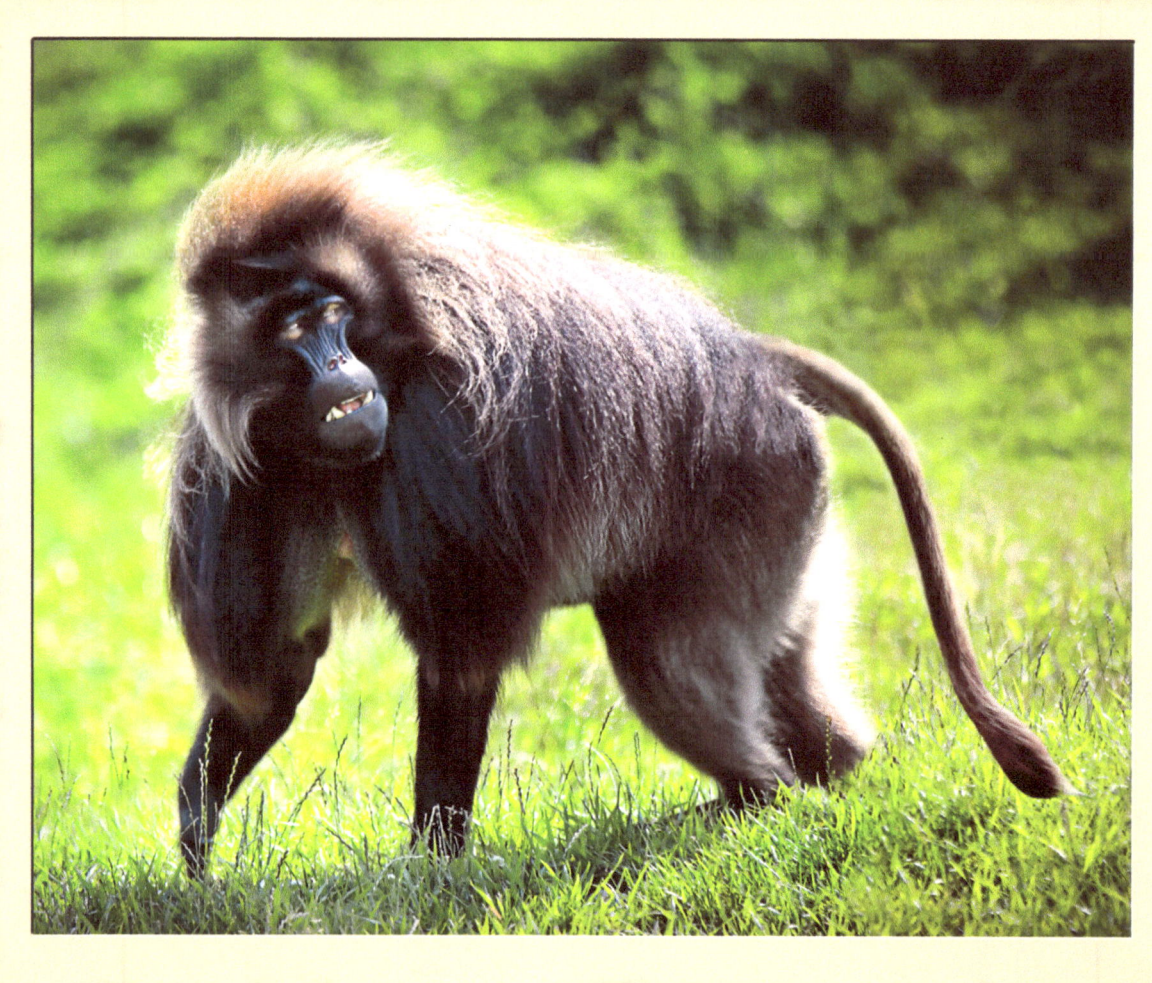

...need to be more assertive with those Bully Baboons...

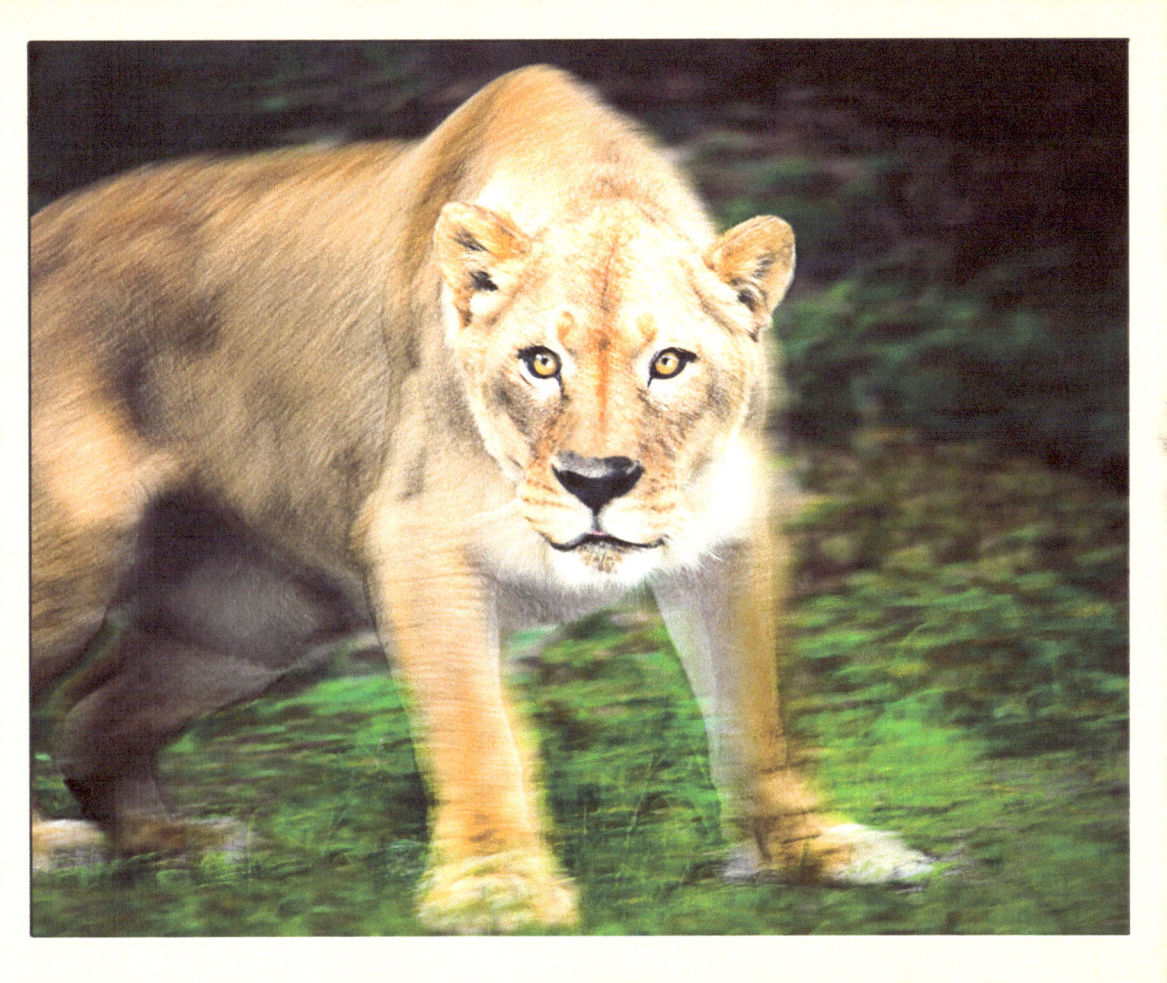

I'm warning you, if you wake me up with that infernal 'clicking sound' one more time...

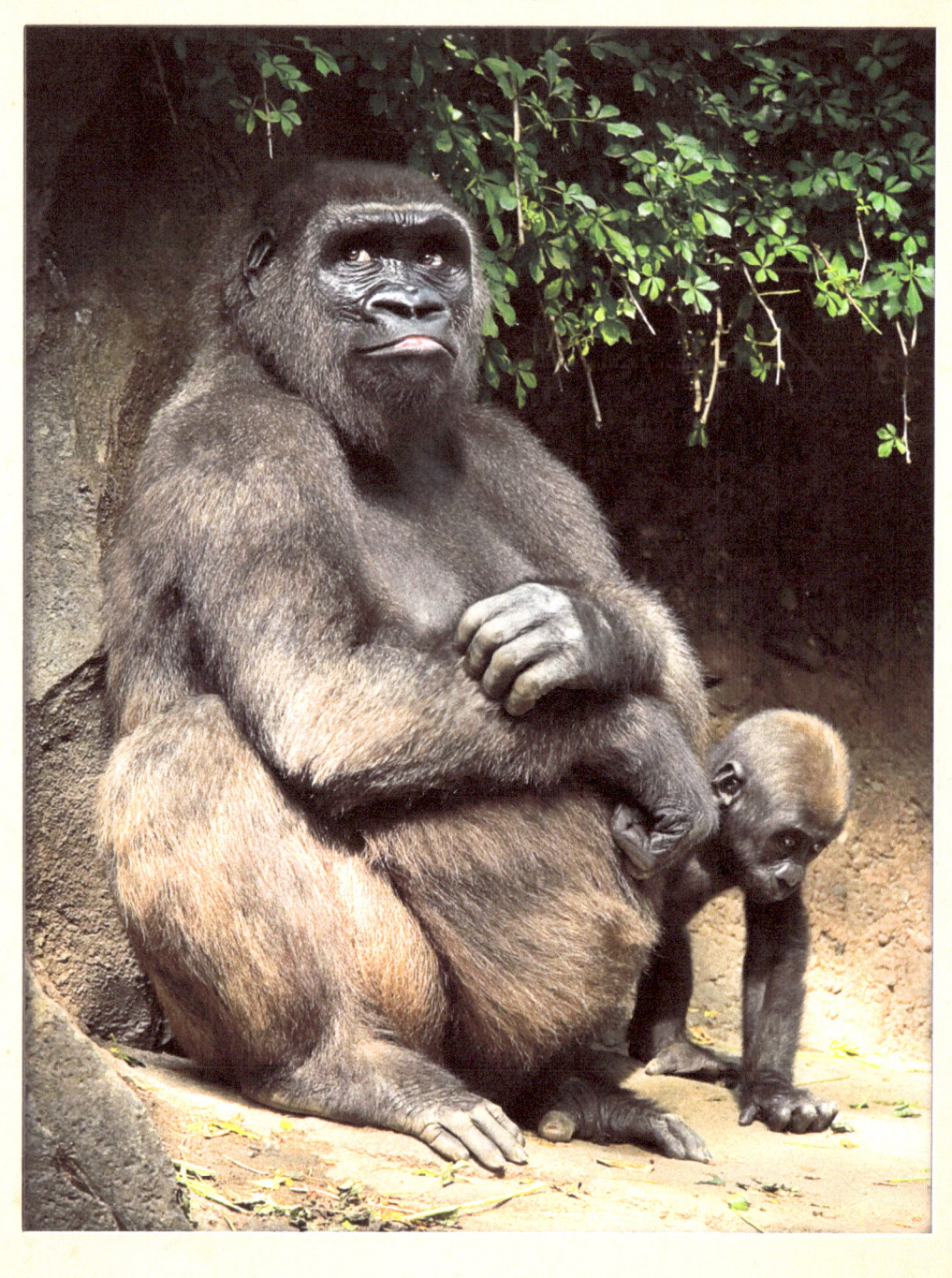

Yep, off He goes, monkeying around while I'm left home all alone with the baby and pregnant AGAIN...

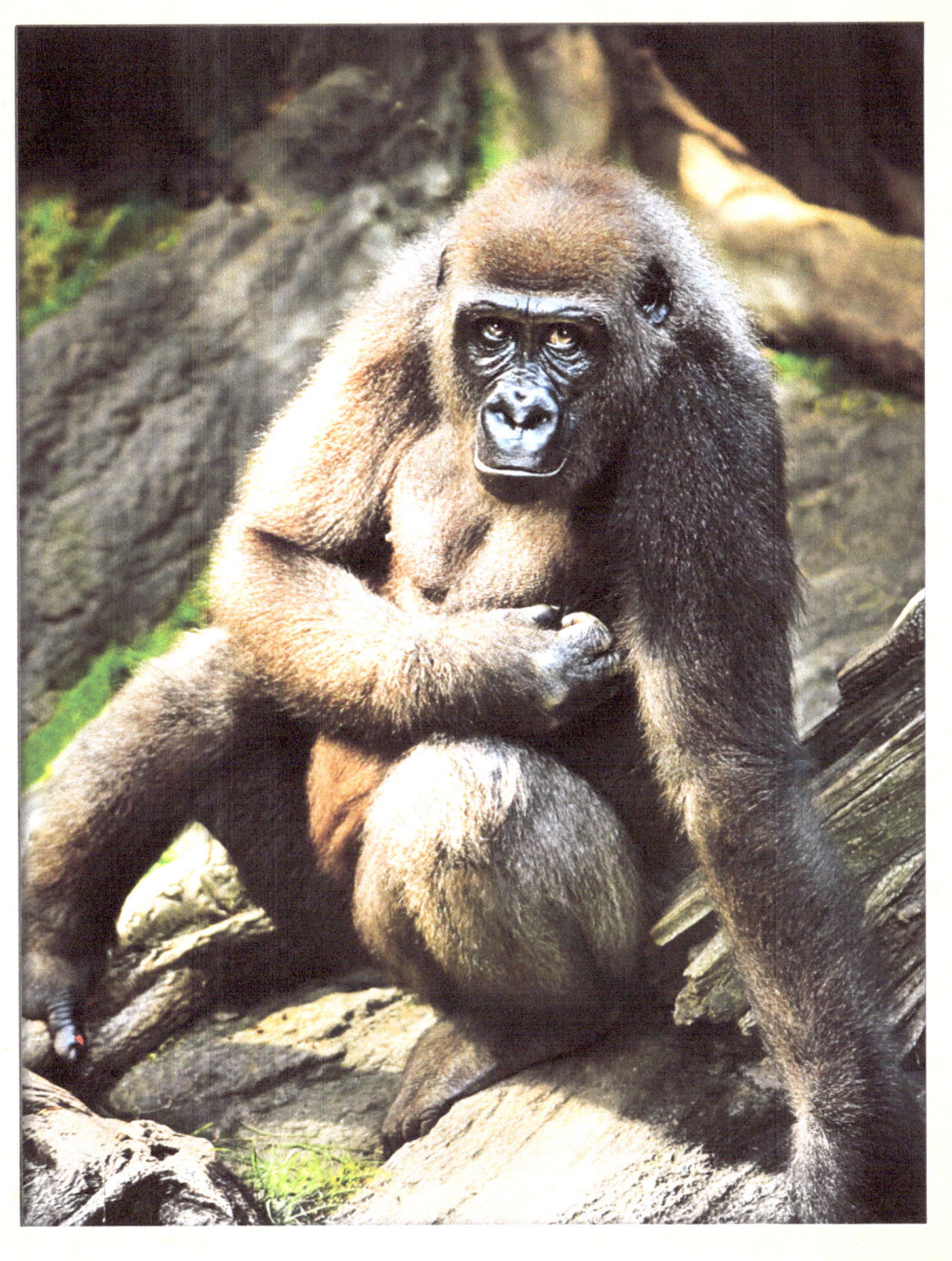

Yeah, baby
I'm waay sexy,
and I know it...

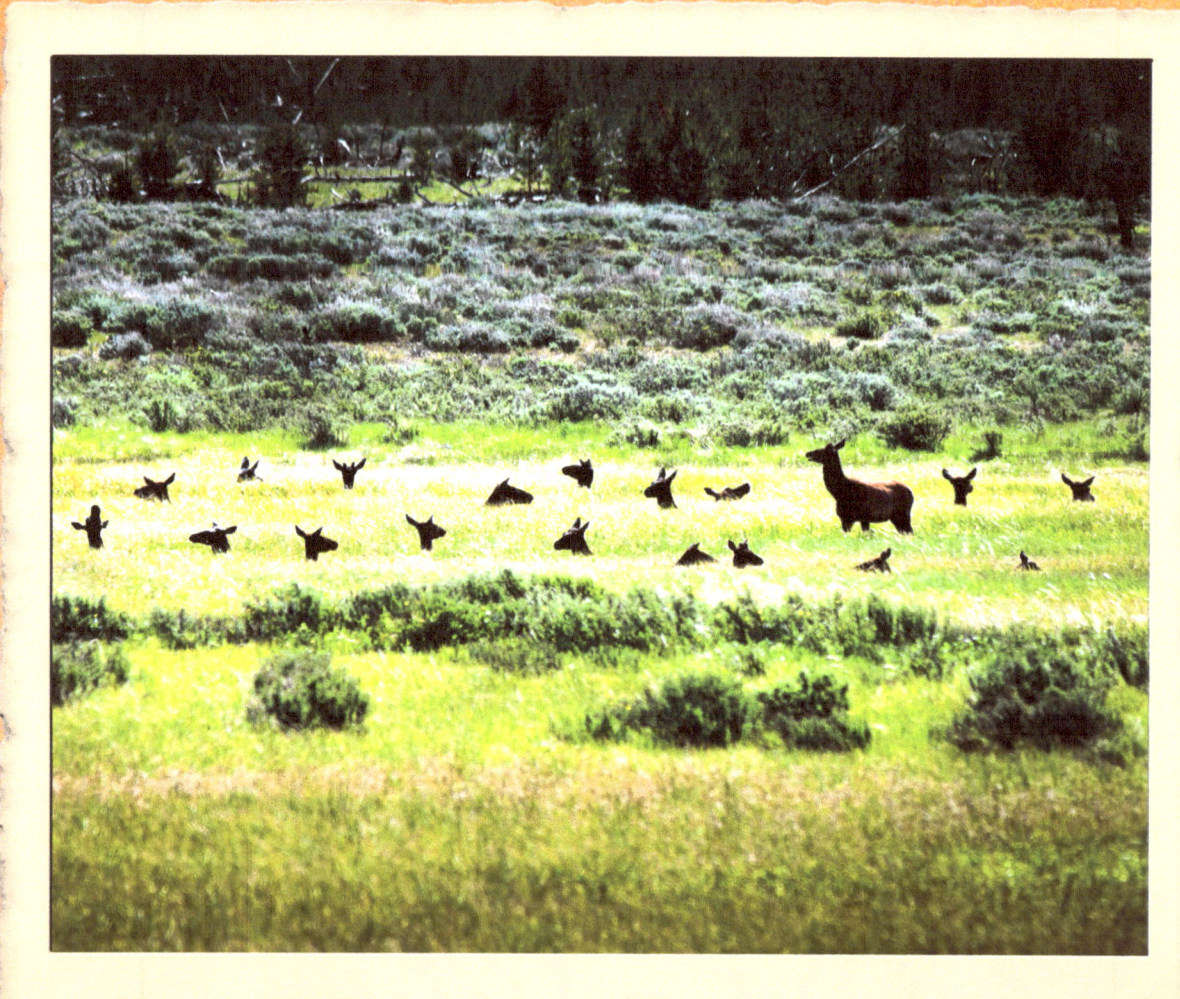

Listen up you maggots!, drop down and give me twenty!!!...

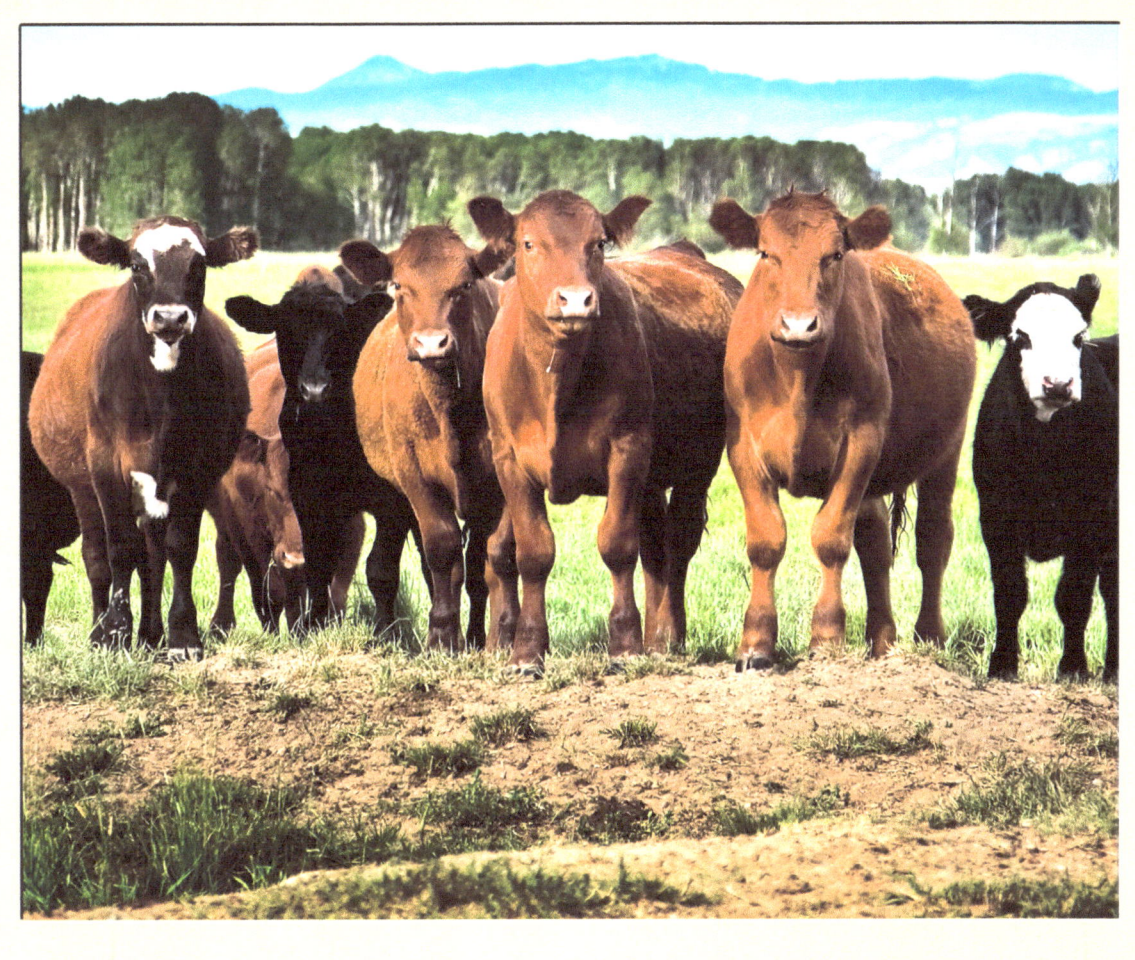

No siree, we don't take kindly to no Bulls... here!!

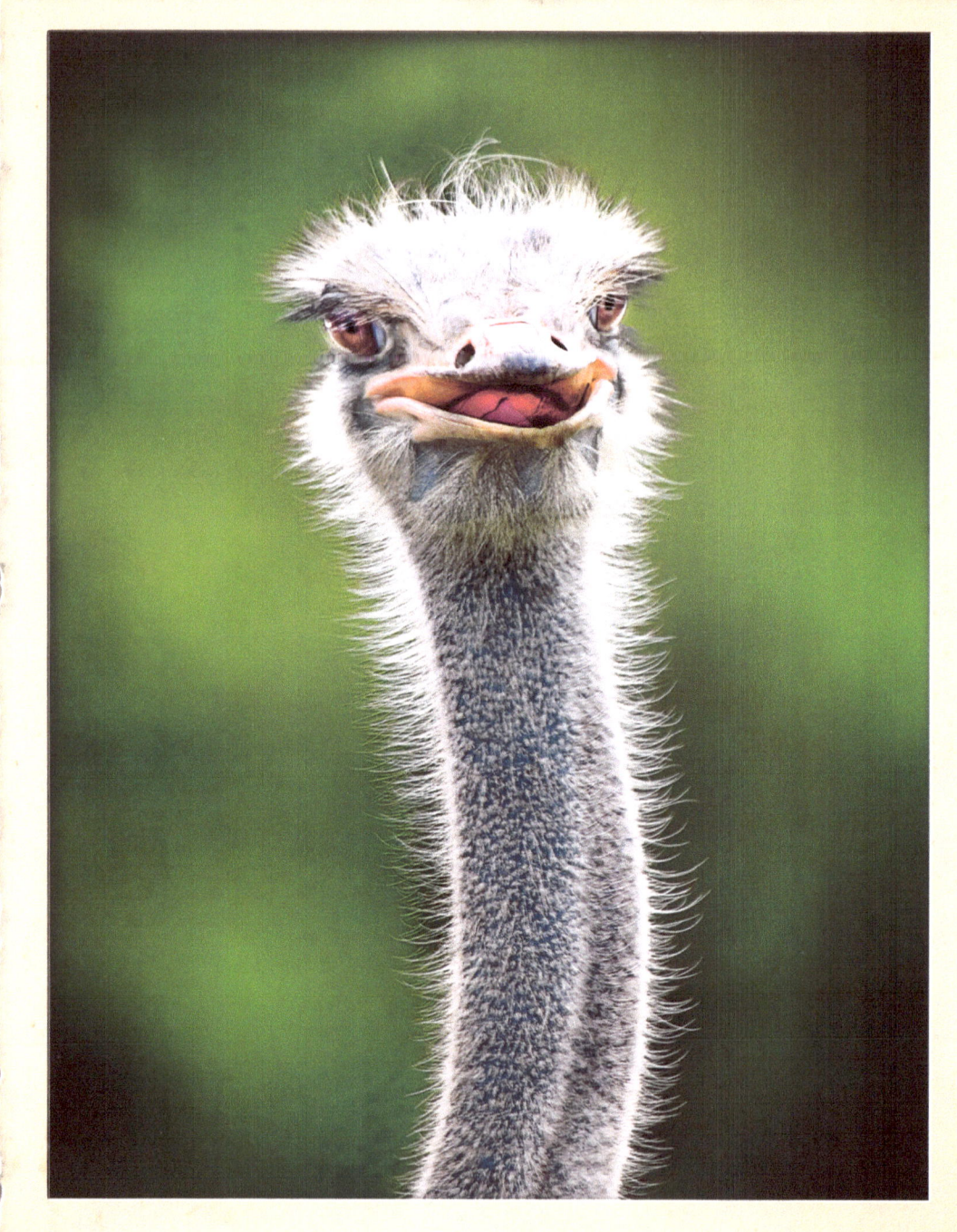

I've been using Frog-ain, you know...

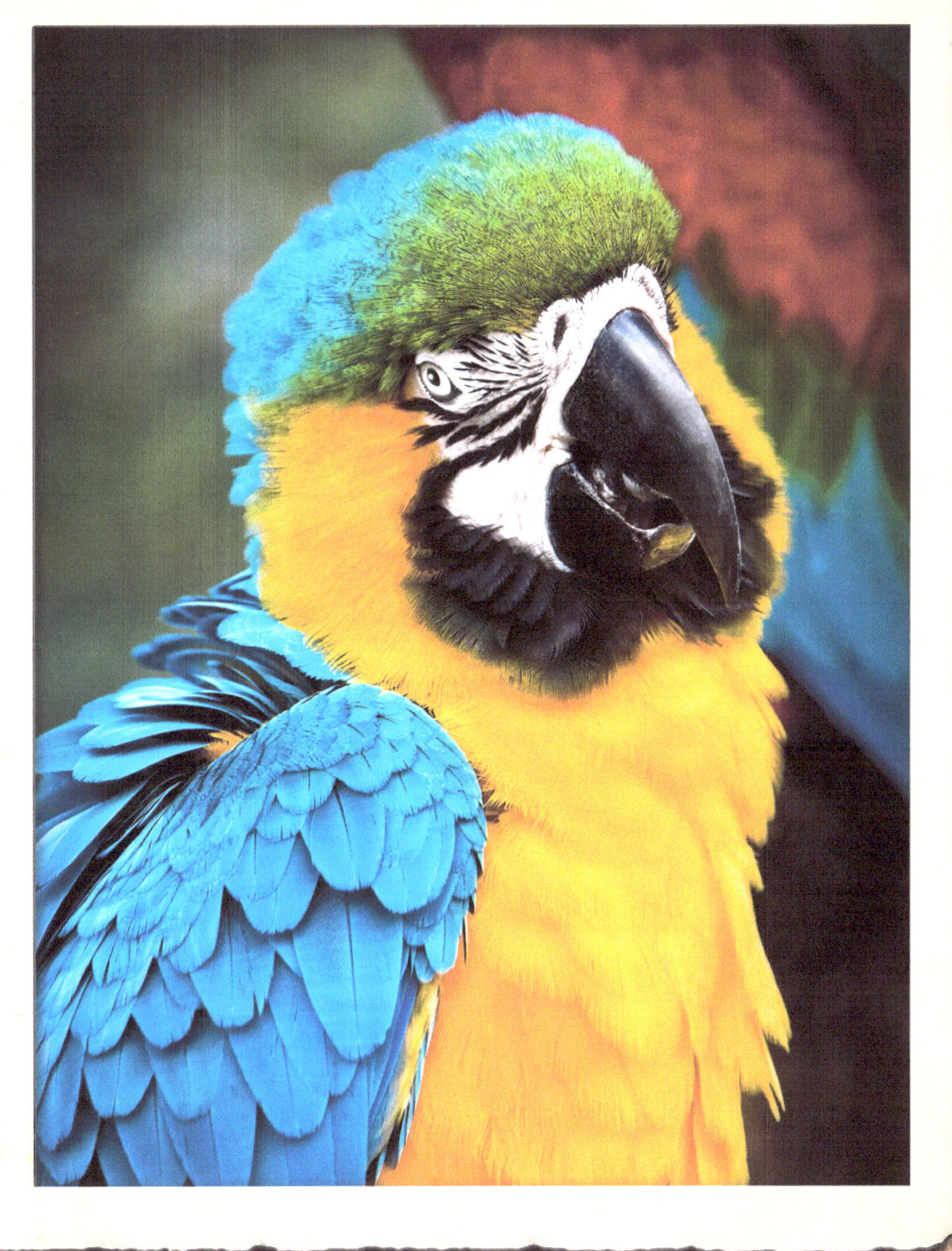

That's all Folks!

www.ingramcontent.com/pod-product-compliance
Lightning Source LLC
Chambersburg PA
CBHW051110180526
45172CB00002B/853